Sheila Baker

KT-590-048

Color and Composition

A Guide for Artists

Color and Composition

A Guide for Artists

Robert Girard

VNR VAN NOSTRAND REINHOLD COMPANY
New York Cincinnati Toronto London Melbourne

Van Nostrand Reinhold Company Regional Offices:
New York Cincinnati Chicago Millbrae Dallas

Van Nostrand Reinhold Company International Offices:
London Toronto Melbourne

This book was originally published in French
under the title *Couleur et Composition*
by Fernand Nathan, 9 Rue Méchain, Paris 14ᵉ

Copyright © for *Couleur et Composition*
by Editions Fernand Nathan, 1969
English copyright © Van Nostrand Reinhold Company Ltd.
1974

Translated from the French by Jüri Gabriel

Library of Congress Catalog Card Number: 73–16705
ISBN: 0–442–30030–1

All rights reserved. No part of this work covered by the
copyright hereon may be reproduced or used in any form or
by any means – graphic, electronic, or mechanical, including
photocopying, recording, taping, or information storage
systems – without written permission of the publisher.

This book is filmset in Bembo and is
printed by Jolly and Barber Ltd., Rugby, Warwickshire ENGLAND

Published by Van Nostrand Reinhold Company Inc.,
450 West 33rd Street, New York, NY 10001, and
Van Nostrand Reinhold Company Ltd.,
Molly Millar's Lane, Wokingham, Berkshire

16 15 14 13 12 11 10 9 8 7 6 5 4 3 2 1

The author and Van Nostrand Reinhold Company have taken
all possible care to trace the ownership of every work of art
reproduced in this book and to make full acknowledgment
for its use. If any errors have accidentally occurred, they will be
corrected in subsequent editions, provided notification is
sent to the publisher.

Library of Congress Cataloging in Publication Data

Girard, Robert, professeur de dessin.
Color and composition.

Translation of Couleur et composition.
Bibliography: p.
1. Color. 2. Composition (Art) I. Title.
ND1488.G5713 752 73–16705
ISBN 0–442–30030–1

Contents

Introduction

Every artist, amateur or professional, needs to understand and appreciate certain rules of technique, color, form, and harmony. Only with a clear and confident understanding of these concepts will he be able to realize his own personal images in the medium of paint.

From our environment, both natural and man-made, and from the works of great masters, the artist can discover much that will be of value to him, but he may not necessarily know what to look for or how to analyse and interpret it. COLOR AND COMPOSITION is intended to guide the reader in his observations and studies, and to show him how to use his discoveries and analyses in his own work. The book will give him a basic knowledge of those aspects of color theory, physics, geometry, and aesthetics which will be of use to him, and it will provide him with practical instruction on the best use of materials and techniques.

1. Color

In common usage the work 'color' refers to colored or coloring substances: pigments, watercolors, tempera and oil paints, various inks, etc.

But color (or more precisely the sensation of color) is the impression produced on our retinas by pencils of colored light.

The color of a body is determined by a substance whose particular coloration is due to certain pigments.

LOCAL COLOR

Every object seen under normal (or white) light has a color which is peculiar to it. This is known as its local color.

The local color of a body can be altered by placing the body under a light which is itself colored. For example, the local color of a lemon (yellow) may appear green in a blue light.

SOURCE OF COLOR

Color is born of light.

'The immense diversity of colors is due to the fact that light is a compound of rays of different types.' (Newton.)

Newton demonstrated that sunlight is composed of an almost infinite number of radiations, ranging from red, which has the strongest radiation (0·8 microns), through all the other colors of the rainbow to violet, which has the weakest radiation (0·4 microns). (See color plate 1, p. 24.)

DISCOVERING COLOR

Experiment. Suitably arrange a pure crystal prism in a beam of sunlight and all the colors of the rainbow (or solar spectrum) will appear on a white screen some distance away. (See color plate 1, p. 24).

THE COLORS OF THE SOLAR SPECTRUM

The colors of the solar spectrum appear in the following order: red – orange – yellow – green – blue – indigo – violet. (Since indigo is a violet bordering on blue, the solar spectrum can conveniently be reduced to only six colors.)

COLOR AND LIGHT

The sensation of color depends on light. In total darkness shapes and colors cannot be perceived by the human eye. The sensation of color therefore disappears when light disappears.

COLOR AND LIGHT INTENSITY

An object appears more or less dark in color according to the intensity of the light that illuminates it. The same color changes value according to whether the light that falls on it is more or less bright.

Observation: Observe the variations in colors and in color values, particularly for shades of green, between twilight and nightfall, by moonlight, etc.

EFFECTS OF DIFFERENT COLORED LIGHTS

The color of an object varies with different colored lighting. Under a yellow light, a blue spot appears green; under a red light, it appears violet. A white screen reflects all the hues produced by the pencils of colored light emanating from a film or a transparency.

Note the variations in the colors of the sky when the sun is setting, and the influences of these on the colors of nature. Also observe, if possible, the coloring of snow in areas of light and shade respectively, first at midday and then at sunset.

Definitions

VALUES

The term 'value' is given to different degrees of intensity of light and shade and, consequently, of color. In painting, the values of a color correspond to tints ranging all the way from the most luminous possible to the point at which the color merges with darkness. (See color plates 2 and 3, p. 24.)

THE QUALITY OF A COLOR

The quality of a color is that which determines its nature. For example, the quality of a red is not to contain either yellow or blue. It is also what differentiates one red from another red: its chemical composition, saturation, etc.

SATURATION

A color is said to be saturated when the smallest possible volume of the color contains the largest possible amount of pigment. Because its pigments are concentrated, a saturated color always has great coloring capacity.

TONES

Tones correspond to the total effect of the values, the qualities, and the different degrees of saturation of a color. (In everyday speech the word 'tone' is often used

in place of 'value' or 'color', as in 'a warm tone', 'a cold tone', etc.)

A tone is also a color considered in terms of the quality that characterizes it, as when people speak of tones that are shrill, muted, dull, lively, rich, monotonous, faded, sustained, broken, etc.

Exercise: Look at the colors around you and try to describe the precise tone of each.

TONALITY

Tonality is the overall impression produced by a number of tones seen as a whole, for example, the greyish tonality of the shadows in a painting, the mournful tonality of a misty landscape, etc.

SHADES

A shade (or nuance) is a very slight difference in quality between two tints of the same or almost the same value.

Example and exercise: Place quantities of the same blue tint into three pans. To the first add a dab of red, and to the second a dab of yellow. The resultant slightly pinkish and slightly greenish blues represent shades of the initial blue. (Never confuse tone and shade.)

COLOR SCALE

A color scale is made up of the successive tones through which a color passes when one adds more and more white (the scale of light tones) or more and more black (the scale of dark tones). (See color plates 4 and 5, p. 24).

TINT

A tint is a color obtained by mixing.

FLAT TINT

A flat tint is a tint applied without contouring. A flat tint is the same at every point on its surface, assuming that all these points are lit identically. (See color plates 5, 12, and 13, p. 24.)

A GRADATED TINT

A gradated tint is obtained by blending the successive tones of a color scale with each other so as to render the transition from one tone to the next imperceptible. (See color plates 2 and 3, p. 24.)

A BROKEN OR DIMINISHED TONE

A broken tone is obtained by diminishing, that is, by reducing its brightness with a dab of grey or a dab of its complementary color. A broken tone is always a tone resulting from the mixture of several colors. (See color plate 8, p. 24.)

The three primary colors

A primary color is a pure, unmixed, uncompounded color, made from a single pigment.

There are three primary colors: red, yellow, and blue. (See color plate 12, p. 24.) They are primary colors because red only contains red, yellow only yellow, and blue only blue.

The three primary colors are also sometimes called basic colors because they form the basis of all other colors, whether spectral or natural.

Exercise: (Recommended medium: gouache). The object of this exercise is to become thoroughly familiar with a primary color and all the tints and shades which can be obtained by mixing it with white and black.

(1) On a sheet of white paper, at intervals of about an inch (2–3 cm.), place small quantities (about the size of a dried pea) of the reds, yellows, and blues in your paintbox. Using a paintbrush or your finger, spread these colors out into patches. Then 'break' them by adding white and black respectively. (Keep these color specimens, so that you will have them on hand whenever you need them.)

(2) On a sheet of white paper carefully prepare tone scales of all the primary colors at your disposal: for example, vermilion and carmine, light blue and dark blue, lemon yellow and yellow ochre. To make up these scales, place a little color (some vermilion, say) and a drop of water in a small pot. Mix the water and the color with a brush to obtain a paste which, though fluid, will cover the paper well.

First put a dab of vermilion on the white paper. Then add a very small quantity of white to the color left in the pot. Carefully mix the vermilion and the white, and place a second dab of color next to the first. Add a little more white and, if necessary, some more water to the paint in the pot. Mix thoroughly until no trace of white or red remains, and you will have a consistent, homogeneous emulsion, the same tint throughout but appreciably lighter than before. Then place a third dab of this color after the second, and so on until you reach a white with the slighest tinge of pink. (The scale can be seen in color plate 5, p. 24.)

Carry out the same procedure with the other primary colors. Repeat the whole process using black instead of white. (See color plate 4, p. 24.)

Keep these scales, and refer to them whenever you want to find the proportion of white or black that must be added to a primary color to obtain a specific tint.

Tertiary colors

A tertiary color is the result of mixing the three primary colors in proportions capable of infinite variation. (Often a certain quantity of white or black is added to the three primary color mix.)

Secondary colors

A secondary color is formed by mixing two primary colors. (See color plate 13, p. 24.)

For example, orange is a secondary color. It is composed of red and yellow, both of which are primary colors.

Observation: Note the position in the solar spectrum of each of the secondary colors between the two primary colors that border it. Why are they arranged this way? For instance, could the orange be anywhere else but between the yellow and the red?

Do red, yellow, and blue produce just one single orange, one single green, and one single violet? How is the diversity of secondary colors obtained?

Exercises: Mix two by two, one after the other, all the primary colors in the paintbox.

Prepare tint scales starting with one primary color and adding progressively larger quantities of the second primary color, whichever it may be (for example, vermilion + lemon yellow).

To prepare this scale, replace the white of the previous scales with lemon yellow.

Graduate each of the tints obtained into two or three tones by adding first white, then black. In this way you can easily produce fifty different tints of green, orange, and violet.

Keep these scales, having first noted in the margin the names of the colors used. This will make it easy to recognize which colors (in what proportions) are required for certain mixes. Make new charts each time you change type or brand of colors (fine artist's colors, watercolors, gouache, etc.).

Complementary colors

Two colors are called 'complementary' when the one consists of what the other lacks in order for their combination to contain the three primary colors: red, yellow, and blue.

Example: Red is the complementary of green, because red + green = red + (yellow + blue).

TABLE OF COMPLEMENTARY COLORS

Red + green = red + blue + yellow = white light.
Yellow + violet = yellow + red + blue = white light.
Blue + orange = blue + red + yellow = white light.

Note: Not every group of complementary colors always shows a primary color in its pure state. For example, take a blue slightly tinted with yellow in the proportion ten parts of blue to one of yellow. The complementary to this greenish blue will, of course, be an orange, but slightly tinted in its turn with the complementary of yellow, i.e. violet (red + blue).

The proportions in which colors must be mixed to make up two complementary tints is not a matter of mathematical precision. It is determined rather by personal taste and by the effect desired.

Exercises: Cut up strips of paper painted red, orange, yellow, green, blue, and violet, and arrange them so that:

(1) A given color is superimposed on its complementary. (See color plates 18, 19, and 20, p. 24.)

(2) The same color abuts upon one or other of the two colors which flank it in the spectrum. (See color plates 21, 22, and 23, p. 24.)

For example, arrange:

(1) A blue on an orange ground. (See color plate 20, p. 24.)

(2) The same blue on a greenish ground. (See color plate 23, p. 24.)

(3) The same blue on a violet ground.

Judge the difference in effect between these three juxtapositions.

Color, light, and the eye

PERCEPTION OF COLORS

In order for us to perceive the color of a light source or of a lit body, the rays of light emitted by the source or diffused by the body must reach our retina.

THE RETINA

The retina is covered with a considerable number of microscopic light-sensitive nerve cells of two basic types, called, respectively, rods and cones.

THE RODS

The rods are sensitive only to black, white, and all the intermediate greys. There are three kinds of cones to be considered:

(1) Cones sensitive to red light.

(2) Cones sensitive to (greenish) yellow light.

(3) Cones sensitive to blue light.

The rods and the cones are linked to the optic nerve which transmits to the brain the impressions it receives.

OPTICAL MIXING OF COLORS

The term 'optical mixing' is applied to the blending of rays of light of various colors as they strike the retina.

Note: In painting, a color mix is the result of mixing two or more different colors made from pigments. As you will see, the mixing of opaque colors on the palette does not produce the same results as the corresponding optical (light) mix.

Light and color

Sunlight can be reconstituted by the optical mixing of all the colors of the rainbow (as in Newton's disk experiment).

Similarly, one can recreate neutral (white) light by optically mixing pencils of blue, yellow, and red light, or pencils of the complementary or secondary colors.

Exercise: Check the accuracy of the table opposite:

Light = red + orange + yellow + green + blue + violet.

Light = orange + green + violet, i.e. (yellow + red) + (yellow + blue) + (blue + red), or (2) yellow + (2) blue + (2) red.

Light = orange + blue, i.e. (red + yellow) + blue.

Light = violet + yellow, i.e. (red + blue) + yellow.

Light = green + red, i.e. (blue + yellow) + red.

Light and colored matter

PROPERTIES OF COLORED BODIES UNDER LIGHT

Every lit body absorbs a certain proportion of the light rays which strike it, and diffuses the rest. A body appears red, for example, because it absorbs the blue and yellow light rays; it reflects only the red rays, and these alone reach our eyes.

Experiment: The aim of this experiment is to demonstrate that an object of a given color reflects only the rays of that same color.

Place a blue object under strong light, and lay a sheet of white paper in its immediate vicinity. The paper becomes tinged with blue. This blue coloration comes from blue light rays interrupted by the white paper, which reflects them in turn so that they finally reach our eye. From this observation we can draw the following conclusions:

(1) The appearance of sunlight is altered by certain physical and chemical properties inherent in the bodies which it illuminates.

(2) While white light contains all the rays of the solar spectrum, a colored light contains no more than the rays corresponding to its own coloration.

Note: It would be a mistake to believe that a red filter, for instance, colors red the rays of white light which pass through it. Instead, it absorbs all the blue and yellow light rays and lets through only the red rays corresponding to its own coloration.

WHITE BODIES

A body appears white when it diffuses all light rays in equal proportion, i.e. when it reflects all the colours of the solar spectrum.

BLACK BODIES

A body which absorbs all the light rays which fall on it appears black.

GREY BODIES

A body which absorbs all light rays in equal proportions, but not completely, appears grey.

The double prism experiment: You will need the following materials: a beam of sunlight, two absolutely identical crystal prisms, and a white screen.

Place the two prisms beside each other in order to obtain two distinct solar spectra very close to each other on the white screen. Move one prism slightly to superimpose one spectrum on the other perfectly. You will notice that the intensity and brightness of the colors have increased.

Red	orange	yellow	green	blue	violet
+	+	+	+	+	+
Red	orange	yellow	green	blue	violet

Then move one of the prisms slightly, so that its green, blue, and violet bands are superimposed on the red, orange, and yellow bands of the other spectrum. You will see that the green and the red, the orange and the blue, the violet and the yellow of the central bands cancel each other out, leaving an almost colorless luminous zone in the middle of the spectrum, while the colors at the extremities still remain bright.

red orange yellow
+ + +
red orange yellow green blue violet green blue violet

↓ ↓ ↓

light light light

So the final result will be:
red orange yellow light light light green blue violet.

Greys

As we have seen, two complementary colors produced from white light reconstitute, when mixed, the white light from which they derive. The same does not hold true in painting; two complementary colors, more or less dense, opaque, and impure in substance, cannot compare with the impalpable nature of light. Mixtures of material colors produce dark neutral tints which turn into very attractive greys once they are lightened with water or some white.

According to the proportions used, one gets greys which are more or less bluish (slight predominance of blue over red and yellow), pinkish (infinitesimal predominance of red), or golden (very slight predominance of yellow over red and blue). (See color plates 15, 16, and 17, p. 24.)

TABLE OF GREYS PRODUCED FROM PAINTS

Black + white = grey. (See color plate 24, p. 24.)
Black + liquid in varying quantities = grey (very attractive in watercolor or wash).
Red + orange + yellow + green + blue + violet = grey.
Red + yellow + blue = grey. (See color plate 14, p. 24.)
Orange + green + violet = grey.

Or, more simply still:

Red + green = grey.
Yellow + violet = grey.
Blue + orange = grey.

Exercises:

(1) Make up a number of grey cards using the various mixes suggested above together with varying quantities of white. Work out, by trial and error, the ideal proportions required to produce any given shade.

(2) By working out its component elements and their proportions, try to reproduce accurately a given grey previously obtained by chance.

(3) Try to reproduce accurately, with all their nuances, the greys in the feathers of a pigeon or in the bark of a birch tree. Try to copy good color reproductions of paintings in which greys predominate; or at least try to reproduce the greys in all their subtlety (suggested painters: Velasquez, Utrillo, Braque, Manet).

The aesthetics of color

Colors emit rays more or less according to their nature, that is, according to the position they occupy in the spectrum between red and violet, and according to their light intensity (the intensity of the light from which they derive).

THE MOVEMENT OF COLORS
Even when projected on to the same plane, some spectral colors appear to detach themselves from the rest and to take up positions a little in front of or a little behind their neighbours.

This impression of movement is quite evident in the work of the masters of color who manage to obtain relief effects from flat tints without recourse to contouring or tricks of perspective.

WARM COLORS AND COLD COLORS
Certain colors, namely the ones with the strongest radiations, seem to be more capable of attracting our attention than others. They are called warm colors, and their scale extends from red to yellowish orange.

The other colors of the solar spectrum with weaker radiations are called cold colors. Their scale extends from bluish violet to greenish yellow. (See color plate 1, p. 24.)

The solar spectrum can thus be divided arbitrarily into two regions, the region of warm colors and the region of cold colors. Each of these regions contains the complementary colors of the other:
Warm colors: red orange yellow
Cold colors: green blue violet.

THE AESTHETICS OF CONTRASTS
A colored light seems brighter in the dark than in daylight. This can be easily verified at nightfall when car headlamps and town lights are switched on.

All colors appear more brilliant on a dark ground than on a light ground, and more sombre on a light ground than on a dark ground. (See color plates 25, 26, 27, and 28, p. 24.)

Principal modes of painting

There are as many techniques as there are painters; but these different approaches can be broadly grouped into four principal modes of painting.

The first and simplest mode consists of applying areas of flat color without any attempt at contouring (i.e. virtually devoid of relief effects). As you can see from the sketch for an Egyptian wall-painting (fig. 6, p. 34) the more or less clear-cut outlines show a characteristic harmony of color and form on the one hand, and an essentially graphic approach on the other. The technique has many advantages. If the decorative effect is a known quantity, the color harmony can be predetermined, the drawing done in advance, and the work carried out by a team.

In short, this mode of painting is characterized by its decorative potential and the facility and simplicity of its technical execution.

The second mode of painting proceeds from the first, enriching and complicating it by introducing the criterion of resemblance. Once a need is felt for a more faithful rendering of nature, with its areas of relief and its spatial depths, the artist has to gradate the tints within paint areas, make use of his knowledge of light and shade, match colors, and even take into account the effects of reflected light. He learns quickly by trial and error that certain colors lose their characteristic quality when mixed with certain other colors (color plate 7, p. 24); for example, green reflected on to a red object darkens, deadens, and dirties the red.

But there is a trick that allows the artist to reproduce the effect of relief while retaining the essential freshness of the color; all that is required is to model each color area on the principle of the cameo, not worrying about the variation in tone caused by induced color. This method was adopted in particular for the illumination of manuscripts. (See color plate 6, p. 21.)

The third mode of painting consists in regarding and handling color as a living element emanating from

light, rather than as an inert and opaque substance that covers things.

The art of painting then becomes chiefly an art and a science of the effects and interactions of light and color. In order to preserve the purity and freshness of colors, and to convey at the same time the subtlety and brilliance of the solar palette, painters adopted the technique of juxtaposing very small areas of paint. As a result of optical mixing, these touches, when seen from a distance, blend with each other; they are not muddied or deadened, as they would be if they were mixed on a palette or on the canvas.

Impressionist painting in the second half of the 19th century exults in light and its play of colors. (See color plates 4 and 5, p. 21.)

A fourth mode of painting, which has come to the fore in this century, more or less abandons the criterion of resemblance. Instead the work of art becomes the reconstruction of a personal vision, and new materials are employed with great freedom to produce effects not derived from nature.

2. Pleasure of the eye

To satisfy the eye is one of the first aims of painting.

The needs and satisfactions of the eye

LIMITATIONS OF THE EYE

The eye must always be ready to receive the light messages emitted in its field of vision, in order to transmit them immediately to the brain as efficiently as possible.

To register a perfect image, the retina should be completely clear of all previously received impressions of light.

In general a retinal image fades almost immediately, provided that the light which produced the impression was normal. A normal light is approximately equivalent to the average intensity of sunlight diluted and filtered by the earth's atmosphere; it suits the eye perfectly inasmuch as it allows it to fulfil its functions with the minimum of effort and fatigue. At opposite extremes, however, brilliant light irritates the eye, and feeble light tires it by forcing it to make additional efforts to accommodate itself to the shortage.

BRIGHT LIGHTS AND THE RETINA'S REACTIONS TO THEM

A light source that is too intense (the sun, for example) has a violent and painful effect on the retina; it can even lead to momentary blindness or a loss of visual acuity which can last for several seconds, even several minutes.

If you inadvertently look straight at the sun, it hurts your eyes and you have to turn your head away. The sun's image on the retina takes a long time to fade, and it is no longer luminous but quite the reverse. Wherever you look – up, down, left, right – a black disk seems to float in front of your eyes: the negative image of the sun.

If you stare for a few moments at a very brightly lit yellow object and then shut your eyes, you will see behind your closed eyelids the image of this object, not in yellow but in violet.

A flash of red light is followed by a green after-image; a very bright blue object produces an orange after-image.

If you look at a red object in full sunlight and then transfer your gaze on to a sheet of white paper, you will observe that the white ground appears greenish. If, under the same conditions, you look at a yellow object, you will see the white paper slightly tinged with a violet halation.

In overcast weather shadows on snow are grey, but on the edges of snow patches lit by the orange rays of the setting sun shadows appear intensely blue.

The duration of the blindness or impairment of the retina increases in proportion to the luminosity of the object or light source observed, and to the duration of the observation.

CONCLUSION

One of the primary satisfactions of the eye is to function under conditions which enable it to appreciate fully all the richness and subtlety of the effects of light and color.

To be able to appreciate fully what it observes, the eye should not be impaired or fatigued either by a prolonged excess or by a continuous shortage of light. Its pleasure and its function consist in being able to pass from one extreme to the other.

How retinal images fade

When a colored light strikes the appropriate cones, their sensitivity diminishes more or less rapidly as they fulfil their functions. They discharge like an electric cell, while the cones unaffected by this particular color of light retain full sensitivity.

Example: If you look straight at the sun, all the cones of the retina are simultaneously and intensely affected. The cones sensitive to red, to blue, and to yellow all discharge and lose sensitivity at one and the same time. In a few tenths of a second the retina becomes blind along the entire length of the surface affected by the sunlight.

Color plate 1. The Jetty at Deauville *by Boudin. (Paris, Musée du Jeu de Paume.) A work particularly rich in nuance and in greys of various hues.*

Color plate 2. The Bridge at Narni *by Corot. A fine example of the 'elaborated study' or 'sketch' which people often prefer to a finished work. Instead of getting lost in details, Corot has concentrated on the scene as a whole. Working in broad outline, his bold brushstrokes capturing each color value precisely, he manages to express simply and powerfully what it was that attracted and moved him.*

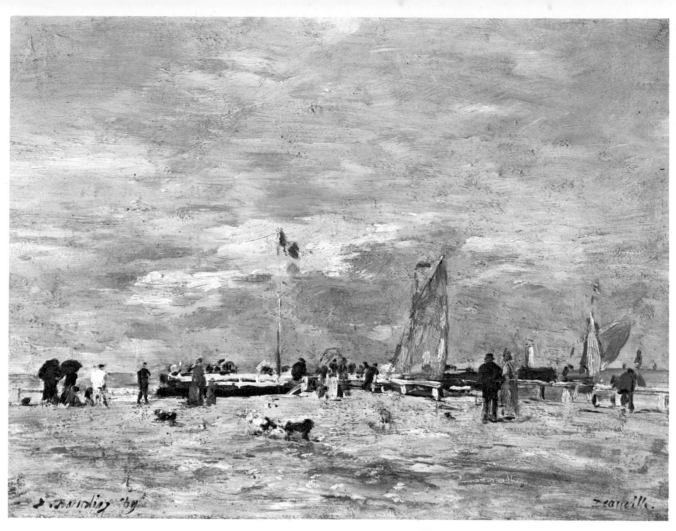

1

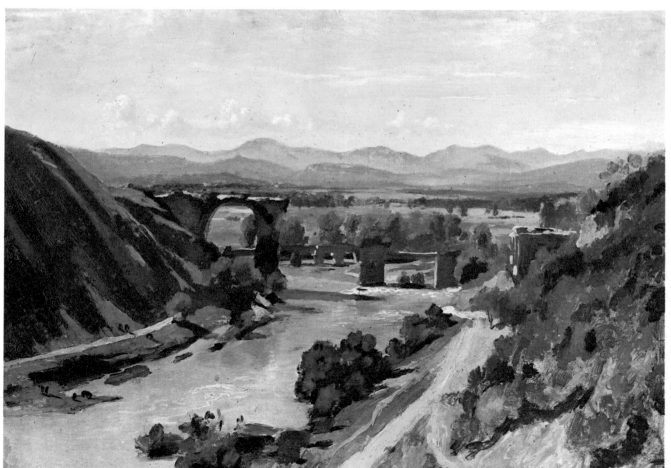

2

B

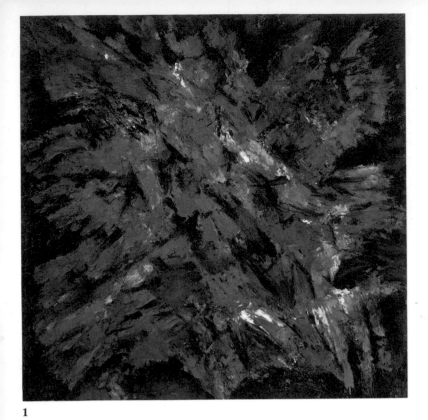

1

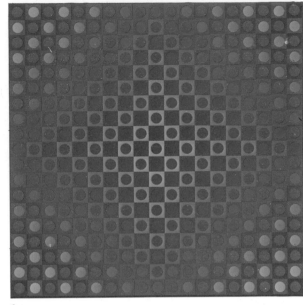

3

2

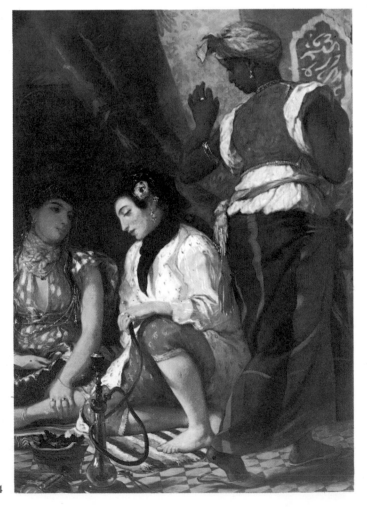

4

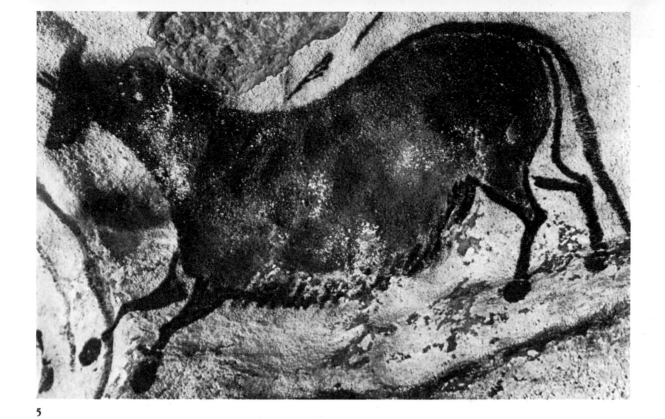

5

6

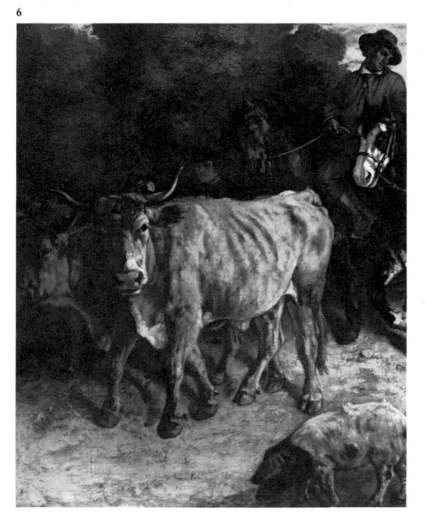

Color plate 1. Nocturnal Bouquet *by Manessier.*
Note the harmony of the warm and cold tints, the
delicacy of the blended passages, and the richness of the
impasto.

Color plate 2. Music *by Saint-Saëns. Detail of*
Aubusson tapestry (Mobilier National, Paris). Note
the quality of the complementaries and the richness of the
value effects.

Color plate 3. Boglar *by Vasarely (1966). In*
Boglar *geometry comes to life, moves, assumes a*
personality and even a soul, in particular through the
play of optical effects; complementary, warm, and cold
colors; and contrasts.

Color plate 4. Women of Algiers *by Delacroix*
(detail; Musée du Louvre, Paris). Delacroix used the
whole range of complementary colors with consummate
skill. His palette, with its harmonious blend of shades
and contrasts, combines power with delicacy.

Color plate 5. Prehistoric painting (Lascaux caves).
Even the actual living rock, with its imperfections and
granulation, reinforces the impression of richness and
vitality of color and form.

Color plate 6. Farmers returning from the Fair at
Flagey *by Courbet. Courbet used the painting knife as*
much as the brush in order to give more 'realism' to his
touch. His mastery was such that he has been called the
'best craftsman painter', that is, the most adept at the
technical skills of the brush, the spatula, color, and
impasto.

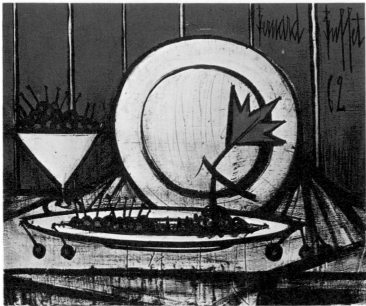

1

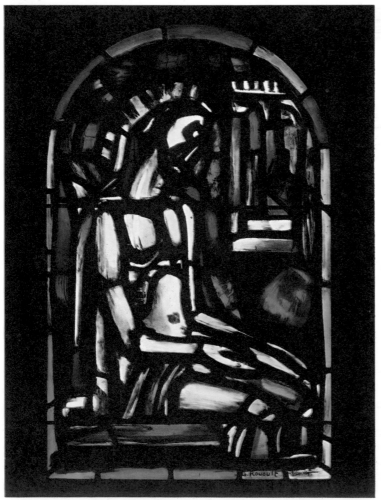

2

3

Color plate 1. Still Life with Cherries by Buffet.
Though essentially sobre and harmonious, the extent and
distribution of the blacks gives the colors an exceptional
intensity.

Color plate 2. Stained glass window by Rouault
(Assy). The weight of the blacks on which the 'lights'
stand out so strongly, the contrasts between the warm tones
and the cold, the sobriety of the contouring with its large
gradated and blended passages, not only produce a
remarkable relief effect, but also give the work an
extraordinarily expressive quality.

Color plate 3. Landscape by Vlaminck. Pressed, worked,
smoothed by the steel blade of the painting knife, the color
of the sky takes on a mirror-like depth. In the foreground, by
contrast, vigorously applied brushstrokes with harsh
contours and a hatched quality (not unlike the stubble which
covers the field) emphasize the movement, the relief, the
intense vitality of the work.

Color plate 4. Women in a Garden by Monet (detail).
The light and its reflections link, animate, and give an
effervescent lightness to all the large flat areas.

Color plate 5. Woman Reading by Renoir (detail). The
technique here is far removed from the two-dimensional
decorative painting of the Egyptian face (fig. 6, p. 34) with
its precise, clear-cut contours.

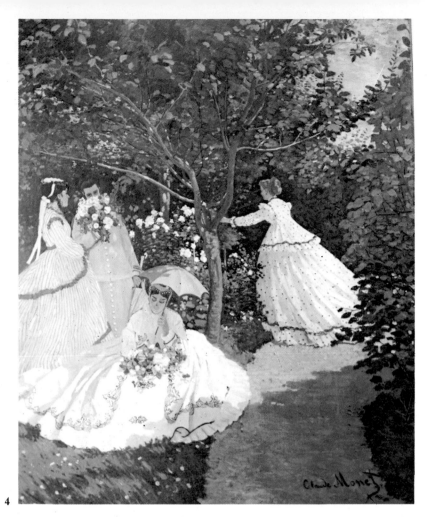

4

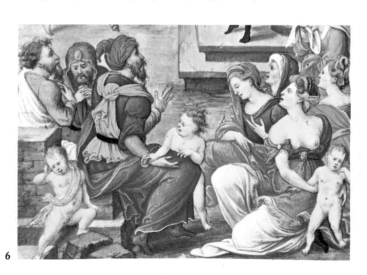

Color plate 6. Miniature. Detail from the Heures du Connétable de Montmorency *(Chantilly). Note the total absence of induced color. Each tint is seen and treated in isolation, in cameo (an art and technique whose aim is to preserve the quality of a tint from the muddying that can result from the admixture of a reflection of a different color).*

6

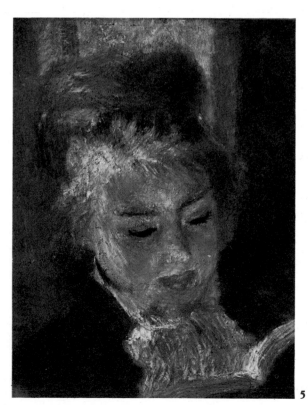

5

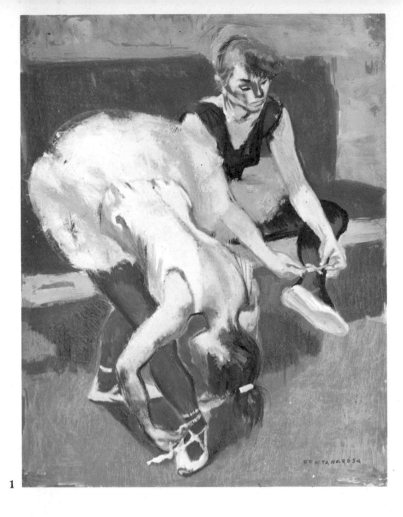

1

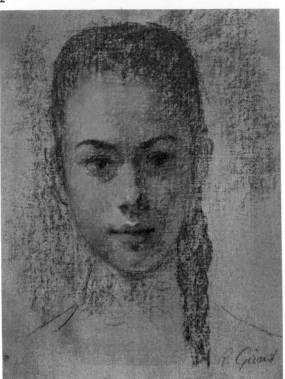

2

Color plate 1. Dancers by Fontanarosa. This was executed in *wax-based paints and wax crayons, which permit more rapid execution than oil paints (shorter drying time) and produce delicate mat tones somewhat reminiscent of tempera.*

Color plate 2. Portrait of a Young Girl by Girard. *Pastel and charcoal. This is a preliminary sketch for a painting, executed in pastel and charcoal on canvas. Pastel can also be used by itself as a medium for painting. Manet, for example, often moistened the pastel to give it greater cohesion and power.*

Color plate 3. Flowers in a Green Vase by Lorjou. *Lorjou uses light in the form of a generous impasto to produce a work that is both concentrated and radiant.*

Color plate 4. Detail from Flowers in a Green Vase. *In this detail the contrasts and the nuances of nature are masterfully recreated.*

3

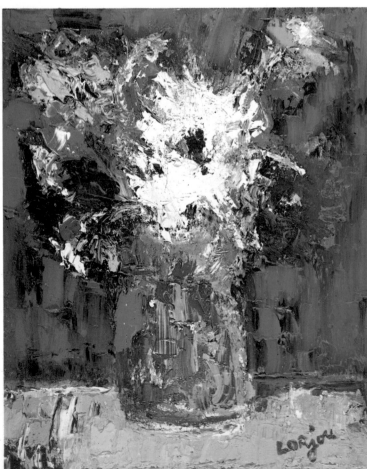

4

Color plate 1. Head of Tutankhamen (Egypt). An almost perfect symmetry seems to have 'fixed' this face for eternity.

Color plate 2. Amphora (proto–Attic). This object illustrates several different methods of decoration.

Color plate 3. Casket in wood and ivory representing Tutankhamen and his queen (detail ; Egypt). From the earliest times people have been aware of the advantages from the decorative viewpoint of using different materials in the manufacture of an artifact. Note the geometric simplicity of the border which highlights the rich detail of the rest of the composition.

Color plate 4. Gold rhython (Scythian).

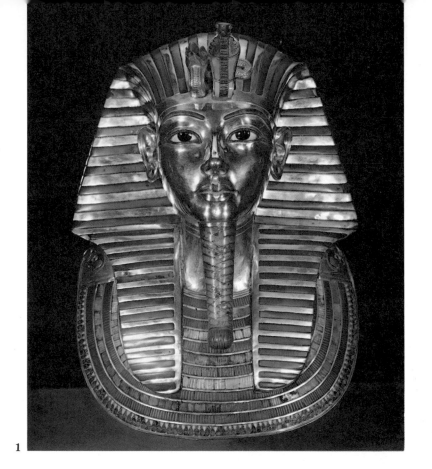

1

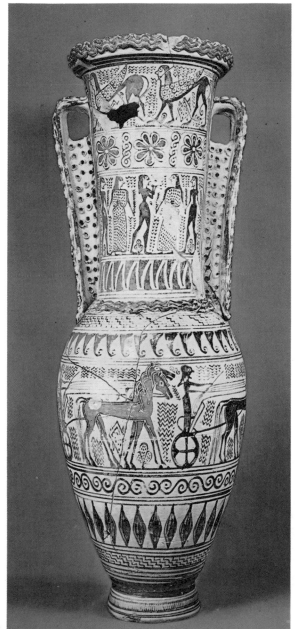

2

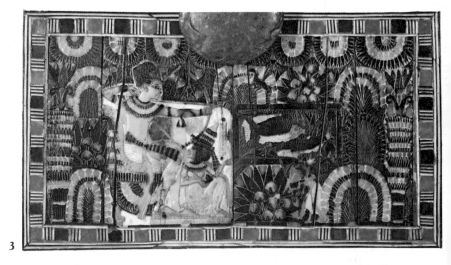

3

4

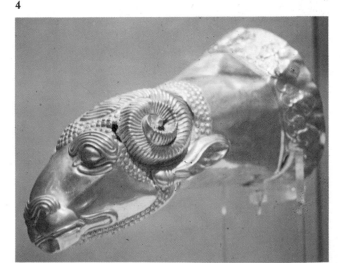

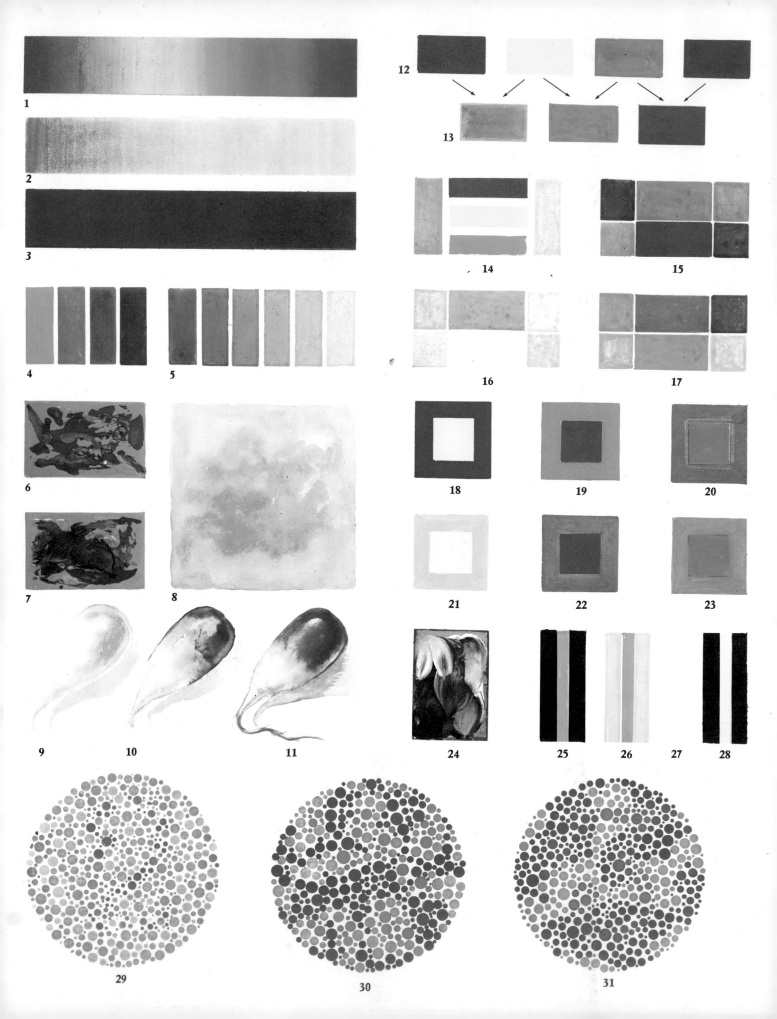

1

2

3

4

5

6

7

8

9 10 11

12

13

14 15

16 17

18 19 20

21 22 23

24 25 26 27 28

29 30 31

Opposite:

Color plate 1. Colors of the rainbow. Red – orange – yellow – green – blue – violet. To get a good violet, use light blue and carmine (vermilion mixed with blue results in brown). In the rainbow, the warm colors extend from red to slightly golden yellow, the cold colors from slightly greenish yellow to bluish violet.

Color plate 2. Gradated tint obtained by applying a sable brush saturated with red on to a very moist sheet of paper. The technique is as follows: fill your brush with a small quantity of red and apply it to a moistened sheet of paper. Using a regular backwards and forwards motion, progressively work the brush from the top of the sheet to the bottom, going over each area once only. The further the brush advances the more pigment it loses, the more it fills with water, and the lighter the trace it leaves becomes.

Color plate 3. Example of double gradation. On moistened paper first gradate black from top to bottom, then gradate red from bottom to top, advancing it steadily and evenly up into the black.

Color plate 4. Scale (reduced) of a broken green, obtained by adding more and more black to the initial hue.

Color plate 5. Scale of a broken violet obtained by adding more and more white to the initial hue.

Color plate 6. Red laid with a knife on a green ground. The qualities of the two colors mutually enhance each other. (See color plate 3, p. 22.)

Color plate 7. A palette knife has been used to mix the same red as in color plate 27 with a still moist green. The resultant mixture is a dark color (dark carmine and dark blue would have produced an almost black color). (See color plates 3 and 4, p. 22.)

Color plate 8. You can easily obtain greys on moist paper by blending yellows, blues, and reds.

Color plate 9. Watercolor technique (in this case gouache with water but without white). The subject is a red radish, and the colors used are red, yellow, and blue. Moisten the paper where you wish to blend colors to obtain transparent effects. Apply blue, a cold tone, to suggest relief.

Color plate 10. When superimposed on this light transparent blue base, the selected red will darken to become violet. (Too sharp a violet can be softened with a dab of yellow.) First apply the red to the highlighted parts (i.e. without blue), so that its full quality and impact remain unimpaired. Continue by mixing the red with the blue as required to obtain the shadow effects.

Color plate 11. Use a carefully dried sable brush to remove the excess color in the highlighted areas. Then finish off with the details, matching values precisely (see 'Applying a flat color wash', p. 37).

Color plate 12. The three primary colors: red, yellow, and blue.

Color plate 13. The three secondary colors: orange (= red + yellow); green (= yellow + blue); and violet (= blue + red).

Color plate 14. A mixture of the three primary colors gives dark grey (left) which can be lightened with white (right).

Color plate 15. The mixture of two complementary colors (green and red) yields greenish greys (above, left and right) or pinkish greys (below, left and right), according to the proportions of green and red used.

Color plate 16. Violet and yellow thinned out with white. The mixture gives very colorful greys (above, left and right). A 'broken or diminished tint' is obtained by adding to yellow an infinitesimal amount of its complementary color, violet (below, left and right). You can also 'break' or 'diminish' a tint by adding a very small quantity of grey to it.

Color plate 17. Greys obtained by mixing white, orange, and blue.

Color plates 18, 19, and 20. Complementary and non-complementary colors.

Color plate 18. Yellow next to violet (a color which does not contain yellow) seems more lively than the same yellow beside a color itself containing yellow (color plate 21).

Color plate 19. Red on a green ground appears more lively than on a red-based ground (color plate 22).

Color plate 20. Blue stands out better on an orange ground than on a ground containing blue (color plate 23).

Color plate 24. Black and white mixed by hand. A mixture of black and white gives greys of different values but of a constant quality.

Color plates 25 and 26. A color appears brighter on a black ground than on a ground having almost the same composition or value.

Color plates 27 and 28. A color appears brighter on a black than on a white ground. To say that it 'stands out' from the black acknowledges the impression it gives of detaching itself from the black and advancing to produce a relief effect.

Color plate 29. A normal eye is not able to decipher the number 3 without some hesitation.

Color plate 30. At the appropriate distance, a normal eye cannot immediately make out the number 36.

Color plate 31. A normal eye cannot see the number 3 without some hesitation.

c

Suppose that the sun were green. Dazzled by the green light, all the cones sensitive to yellow and to blue would rapidly cease to function, i.e. they would immediately become 'blind'. Only the red cones unaffected by green would continue to operate. Therefore the image of a green sun would appear red the moment you stopped looking at it.

Stimulation of the retina

A second source of pleasure for the eye lies in regular stimulation of the nerve cells of the retina.

The satisfaction of the eye contemplating a work of art or a natural spectacle depends on the quality, number, frequency, and the variety of the stimuli undergone by the retina.

If these stimuli are feeble, or the surface of the retina on which they act is drastically curtailed, or if they follow each other without perceptible variation in intensity, coloration, surface, form, speed, rhythm, etc., the functions of the eye and, consequently, its reactions, are scarcely noticeable and lack interest. For example, a smooth, monotonous wall or a cloudless sky give less pleasure than a wall decorated with different markings, motifs, colors, and materials, or a cloudy sky at sunset.

RESTING THE EYE
The eye experiences a certain fatigue when it contemplates a work that is too rich in arabesques, colors, materials, etc. A few whites or areas of neutral color introduced into such a work will act as rest zones. If distributed well, they will not flatten the overall effect, but rather, by virtue of the contrast they offer, will enhance the qualities of what surrounds them.

Whites or areas of neutral color in the work of masters such as Velasquez, André Marchand, Braque, Matisse, Manet, or Cézanne fulfil the same aesthetic function as a momentary silence in a speech or a piece of music.

VISUAL FATIGUE, MONOTONY, HABITUATION
If, for example, you look long and hard at a patch of red, the red appears to lose some of its quality and at the same time to become a little darker. What is happening?

By staring for some time at a red, the cells sensitive to this color become fatigued; they 'run down' rather like an electric battery in use. Each cell in the retina functions perfectly only when its periods of work and rest alternate at an extraordinarily rapid rate.

Any strong and prolonged stimulus produces fatigue and, as one becomes accustomed to it, indifference and boredom, if not pain or temporary blindness.

The boredom of a large monochrome area can be relieved through the interplay of brushwork, variations in texture and materials, etc.

Aesthetics

COLOR AND WHITE; COLOR AND BLACK
Just as colors appear to 'move' according to their degree of contrast, brightness, warmth, or coldness, so too whites, greys, and blacks can, to some extent, stand out from each other, with the strongest contrasts determining the most marked relief or 'movement'. (See figs. 1, 2, 3, and 4, p. 29.)

Similarly, brightly lit bodies are thrown into increasingly clear-cut relief the greater the contrast between their shadows and their lights, their blacks and their whites.

A grey snowflake against the background of a grey sky merges with the sky. But when it suddenly passes very close to us, with the dark screen of a pine tree or of a wall in shadow behind it, it seems quite white.

The following experiments will help you to appreciate the various aesthetic effects of a color standing out first from a light or white ground, then from a dark or black one:

(1) On a sheet of drawing paper as a white ground, paint a number of spots of different colors, leaving a white space of $\frac{1}{8}$ in. (3 mm.) between each. Judge the resulting effect.

(2) Cover about half the total surface of white space with black. Consider the new effect. Compare the effects produced by the half with the black background with those of the half without it.

(3) Carry out another exercise of the same type, making the intervals of white between the colored spots narrower (the thickness of a pencil line, for instance). Again, fill in about half of these intervals with black. Compare these effects with each other and with those of the two previous exercises.

(4) Carry out another similar exercise with very broad and irregular white areas. Fill these with black in the same way as before and compare the effects obtained.

(5) Note carefully the different aesthetic effects produced by contrasts between black and white, colors and white, and colors and black, then analyse similar effects in works of art over the centuries, such as those obtained:

(a) By the use of dark areas on a light ground or vice-versa (Chinese backgrounds, the linked motifs outlined in black which decorate Greek and Cretan vases, etc.);

(b) By the relative importance of the black or dark line containing an area of color (Egyptian paintings, manuscript illuminations, colored woodcuts, Épinal devotional figures, ancient and modern stained glass windows, etc.);

(c) By the way in which outlines of varying degrees of darkness and width enhance or give particular vitality to the colors they contain (for example, in paintings by Cézanne, Suzanne Valadon, Gauguin, Braque, Modigliani, Mon-

drian, Villon, Picasso, Buffet [color plate 1, p. 20], Rouault [color plate 2, p. 20], etc.).

THE AESTHETICS OF COMPLEMENTARY COLORS

The different aesthetic effects of colors placed next to their complementaries can be appreciated by studying the following examples on p. 24:

(1) A yellow on a violet ground (color plate 18);
(2) A red on a green ground (color plate 19);
(3) A blue on an orange ground (color plate 20).

Then compare these effects with:

(4) A yellow on a greenish or orange ground (color plate 21);
(5) A red on a violet ground (color plate 22);
(6) A blue on a purple or greenish ground (color plate 23).

In like manner you can appreciate the different aesthetic effects produced by the weight, disposition, quality, and relative intensity of complementary colors in paintings by old, modern, or contemporary masters. (See, among others, color plates 2 and 4, p. 18, and color plates 3 and 4, p. 22.)

Experiments: Lay a yellow tint on a white background, and surround it with different violets, some lighter than others, some tending in varying degrees towards blue and red, respectively. Consider the different effects produced by the more or less violent contrasts between the single yellow and the different violets which encircle it.

Carry out similar exercises, starting with a red area surrounded by several shades of green, some darker than others, some tending in varying degrees towards yellow and blue, respectively; then proceed to a blue surrounded by different tints of orange, some lighter and some darker, some tending in varying degrees towards yellow and red, respectively.

Evaluate the different effects obtained in each instance so that you will be able to reproduce them at will when you paint.

Practical advice: If a tint is judged to be too dull, its brightness and impact can be enhanced somewhat by enriching it with a few touches of its complementary color.

Often you may be quite satisfied with a color seen in isolation on the palette, but once it takes its place among other colors it seems to lose some of its brilliance and impact. In the majority of cases you can counteract this tendency by applying a few dabs of its complementary either to the color itself or to the area immediately surrounding it.

Suppose, for example, that you wish to produce a painting of a valley bathed in the hot, vivid light of summer. Suppose that you prepare colors which, in isolation, seem completely satisfactory: the bright blue of the sky, the greens of the pines and the fields, partly in sun and partly in shade, etc. But, as soon as you apply these colors, you see that they have lost the quality or the brightness they had when you mixed them individually on the palette. How can this lost brilliance and impact be restored? Certainly you could repaint with fresher and brighter colors, but this would be a long and rather boring job. Why not take advantage, instead, of the contrasting complementary colors? You can restore luminosity to the blue of the sky by introducing orange, whether in the form of orange lettering, an orange aeroplane, or an orange roof on a house. You can revitalize the greens of the fields with red splotches (poppies, a milestone, a piece of clothing, the bodywork of a car), and the mauve tint of a shadow on a white road with a few yellow flowers or a patch of yellow sand.

Experiment: Put two complementary colors side by side – red and green, for instance – and let one of them run slightly into the other. Where they mix, a very dark grey will appear. You already know that a grey is obtained by mixing two complementary colors. (See color plates 15, 16, and 17, p. 24.)

Advice: As you paint, it is useful to remember all the effects obtained in previous experiments and to employ them to achieve the desired ends. When doing a rough draft, avoid 'muddying' the colors by unintentionally mixing complementaries.

COMPLEMENTARY BROKEN COLORS

A painter ought to know his palette, that is, the colors he uses and all their potential effects.

Complementary hues are not always used in their pure states; usually they are broken, lightened with white, darkened with black, or weakened by another color. (See color plates 2 and 4, p. 18.) It is useful, therefore, to draw up a sample chart of the principal effects that can be obtained by using complementary broken hues under normal conditions.

Experiments: Add white to red. Apply the resultant pink to a white ground, and surround it with different shades of green obtained by adding varying quantities of white and black, respectively. Compare the effects of the pink in contact with these different shades of green which cover the full range from pale to dark. (See color plate 4, p. 18.)

THE PLEASURE OF THE EYE AND ITS AESTHETIC DEMANDS

The eye is the natural organ of sight. How fully and with what degree of success it can carry out its functions depends on how well suited it is to its purpose of perceiving and taking note of the specific qualities of nature and their aesthetic effects.

THE AESTHETIC QUALITIES OF NATURE

Nature is perpetual motion; it is nothing but contrasts, more or less rapid transitions from one extreme to another, actions and reactions.

The aesthetic qualities of nature seen as a whole could be said, then, to comprise 'contrasts', the result of infinite variety, and 'rhythms', the manifestations of life in movement.

THE AESTHETICS OF CONTRASTS

Contrasts of values, colors, forms, materials, and lines should be determined and arranged in such a way as to reflect the artist's conception and to reinforce the expressive quality of a composition. (See Chapter 11.)

Observations (the study and critical analysis of color areas):

(1) *Large color areas*

When the different color areas are very large, you instinctively take a step back in order to get a better impression, thereby enabling the eye to pass rapidly from one area to another. Conversely, a very large area of color seen too closely might impinge upon the whole eye and tire it by the uniformity of the effect produced. For any given work there is an ideal viewing distance at which its aesthetic qualities are most fully enjoyed. You would not look at a poster, for example, in the same way that you would look at a postage stamp; you move away from the one and come closer to the other.

(2) *Contrasts of form, line, and proportion*

Place sheets of tracing paper on a number of black and white reproductions of modern paintings. On each sheet trace the outline of the main color areas. Fill these areas with shading, varying the degree of lightness or darkness to match its equivalent in the reproduction. Then study the distribution, the proportions, and the shapes of these areas in the context of the rectangle of the painting. Try to analyse its apparent balance and rhythmic quality.

ANIMATION AND LIFE IN A WORK

To animate an area, a form, a work, is to enrich it with different effects capable of exciting the nerve cells of the eye.

How, for the pleasure of the eye alone, can you 'animate' a uniform surface devoid of any particular interest? Several different methods are outlined below: (the surface in question must, at a certain distance, give the impression that it consists of a single color.)

(1) A few feet or metres away, your neighbour's jacket appears to be an even grey; however, as you get nearer you can clearly distinguish different colored threads.

Experiment: On a palette prepare three shades of grey (bluish, pinkish, and golden). Then brush a dab of bluish grey on white paper, followed by a dab of golden grey and a dab of pinkish grey. Continue the process, alternating the shades of the dabs.

Next mix the three shades of grey on the palette to form a single grey, and spread it alongside the first exercise. Get far enough away to judge the effects obtained. Note that the first exercise pleases the eye more than the second; it appears less flat, its overall tonality is more vital, and the brushstrokes seem more vibrant.

(2) Arrange an object with a monochrome striated surface so that its angle to the light varies. Note that the object appears lighter when the light rays are parallel to the grooves, and darker when the same rays are perpendicular to the grooves. In the latter case, the raised aspect of each groove has thrown its shadow on to the surface of the object, thereby making it darker. (See fig. 5.)

Experiment: Prepare a colored paste thick enough to spread with a hard brush or with a comb, and deploy strokes so that none of them runs in the same direction in relation to the light source as its neighbour. Make sure that the hard bristles of the brush or the teeth of the comb cut grooves in the colored paste. You can, if you wish, leave some white areas between the strokes. If necessary you can also vary the color of the ground.

Then re-apply the original colored paste, smoothing it to obtain an even surface. Compare the difference in effect between the two exercises.

(3) A pigment, whether of ink, watercolor, gouache, or oil paint, becomes lighter and more transparent the more it is diluted with water, oil, or mineral spirits.

You can add life to a ground or an area that appears excessively uniform by applying here and there a more or less transparent glaze.

Experiment: To a regular unbroken surface apply the same color now in a more fluid, now in a less fluid form, to obtain juxtaposed passages of slightly differing values.

(4) A concrete wall has a single, uniform tint. Using a machine designed to spray on coarse sand or small stone chippings mixed with mortar, a workman could cover the wall with a coating which, through monochrome, would be enriched by the raised facets of the countless stone chippings and grains of sand. The play of light and shade on all this minute faceting therefore serves to 'animate' the surface of the wall.

Experiments:

(a) *Use of a spray or atomizer*

On to a uniform ground covered with a transparent tint (i.e. diluted with a certain quantity of liquid) spray a less fluid color with a device known as a fixative sprayer (generally used to fix charcoal or pastel). Make sure you keep the correct distance away from the surface on to which those myriads of minute specks of vaporized color are to be sprayed (if you are too close the tiny flecks of color flow into each other, forming splotches and runs). You can also use a small, extremely fine mesh metal grill which is held above and parallel to the surface to be 'animated', and along which you rub a hard bristled toothbrush soaked with the chosen color.

(b) *Use of the painting knife, bristle brush, etc.*

A monochrome ground can also be 'animated' by the addition here and there of less fluid color applied in varying thicknesses with a painting knife or one's finger. You can also mix in substances which will

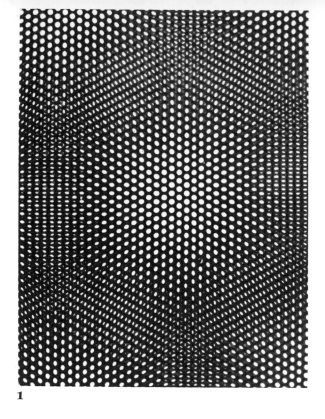

1

Fig. 1. Jeu de Trames *by Stein. The ordered, simple, geometric beauty heightens the intense animation produced by the variety of forms and values. Depending on the angle from which it is viewed, it appears even richer to astigmatic eyes.*

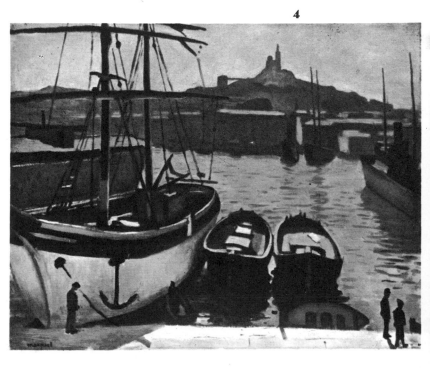

3

Fig. 3. Suspended volume *by Soto. The enormous variety of values, lengths, widths, and angles of inflection, brings this remarkable work to life and gives it a three-dimensional quality.*

Fig. 4. Port of Marseilles *by Marquet. In this figurative work, as in the two previous examples, the passages which appear to stand out most noticeably from the background are those which show the greatest degree of contrast; those passages which seem the furthest away contain the values closest to each other.*

Fig. 2. Curtains *by Seuphor. Note the apparent recession of values which are nearly identical to the contrasts in the foreground.*

2

4

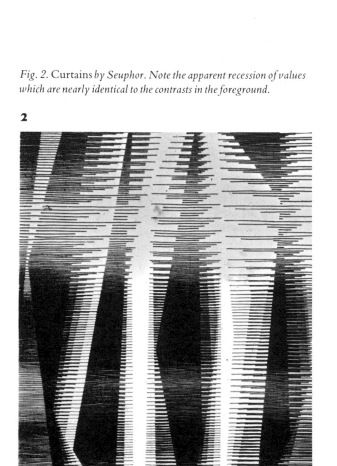

further enrich its effects: varnishes, glues, inks, wax, plaster (in very small quantities, in view of the risk of cracking), or gummed paper.

Observations: Study and note the different 'procedures for the animation of surfaces' employed by painters such as Picasso, Braque, and Rouault. Observe also the significance and effect, on the one hand, of light touches, particularly in the foregrounds of works by landscapists such as Théodore Rousseau and Diaz de la Pena, and, on the other, of additional applications of color in the case of almost all the great masters: Rembrandt, Pissarro, Courbet, etc. (See color plate 6, p. 19, color plates 1 and 2, p. 20, and color plates 2 and 3, p. 22.)

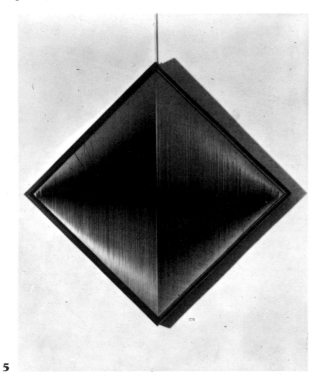

5

Fig. 5. Dinamica visiva *by Costa.*

(5) Place side by side two very small spots of color, for example, red and yellow. At close range the red spot can be clearly distinguished from the yellow one; the eye's differentiative capacity is effective. Then slowly walk away until you reach a point at which you can make out only one single orange tint; the eye's differentiative capacity is no longer effective. Thus, at a sufficient distance, very small spots of different colors appear to merge into each other and, through optical mixing, produce impressions of a single color.

From observations such as this sprang the experiments of the Impressionist school of painting. Study, first at close range, then from a distance, the work of Impressionist painters such as Monet, Renoir, Sisley, and Pissarro.

3. Painting: general points and techniques

Basic requirements for a painting

In order to execute a painting, certain basic ingredients are required:
(1) Colors, i.e. pigments;
(2) A vehicle, i.e. a liquid or bonder to ensure that they will remain permanently fixed;
(3) A support;
(4) A ground or prepared surface;
(5) Tools to spread and work the color;
(6) Protective varnishes.

COLORS

How can a painter capture and represent the radiance of a color composed of light, which is by its nature impalpable and uncontainable? A painter cannot create light; he can only manipulate certain pigments, whose quality cannot possibly rival that of light. The painter cannot duplicate the effect of light; he can only, using such means as he possesses, create a corresponding effect.

In earlier eras, the painter's first task was to obtain from nature colored and coloring matter and to reduce it to a solution or a very fine powder, the minutest particles of which are called 'pigments'. The first pigments were obtained from the soil (red ochre, yellow ochre, metallic oxides), from vegetable extracts, and from products of calcination. Ancient civilizations then discovered other coloring agents obtained either by burning native earths (burnt earth colors), or by treating certain metals (reds from iron oxide, green from copper), or the famed purple which was extracted from molluscs.

Today chemistry offers us a palette of extraordinary richness, but the greatest colorists are those who know how to draw the maximum effect from a minimum of basic colors. A rich palette does not necessarily mean a good painter.

'In reality one works with a few colors. What gives the illusion of multiplicity is the fact of their having been put precisely where they ought to be.' (Picasso.)

VEHICLES AND BINDERS

Vehicles and binders are more or less liquid substances which hold pigments together and not only enable them to be spread in layers of varying thicknesses on a support, but also ensure that they will remain there.

Water was the medium first employed to this end, and even today we still use numerous water-based techniques: fresco, watercolor, wash, ink, gouache, tempera, etc.

But a color made up of pigments and water alone would revert to dust as soon as it dried. For a paint to adhere to its support, it has to contain a binder.

The earliest binding media were glues (made from bones and animal skins), vegetable extracts, fats, resins, and oils. Not long afterwards the remarkable properties of casein (a glue made from milk) and white of egg (a particularly clear glue) were discovered.

Man realized very early that he needed to increase the flexibility of paint; to make it more fluid or more oily, thinner or fatter, to extend or shorten its drying time. The Egyptians, the Cretans, the Greeks, and the Romans used wax as a binding medium. Its pliability and plasticity permit a subtle and delicate contouring. Even today wax-based paints are still used.

But the most widespread medium, particularly highly regarded by the painters of the Renaissance, was 'tempera', an egg and water-based paint. Egg yolk contains a very high proportion of fatty matter, which facilitates contouring; it also has the property of being soluble in water. (See fig. 3, p. 33.)

SUPPORTS

A support is the surface on which a painting is executed.

The supports most commonly used in schools are different sorts of papers.

The supports used for oil painting include canvas stretched on a wooden framework, hardboard, wood (fig. 2, p. 33), plywood, and polished metal. All these supports are given a ground to ensure perfect paint adhesion and prevent deterioration.

(1) *Papers*
Papers specially prepared for wash, line drawing, crayons, gouache and tempera, oil, watercolor, or pen and ink are easily obtainable commercially. Some papers are equally suitable for wash, line drawing, and pen and ink; others for wash, line drawing, and gouache. Pastel requires a specially treated paper.

(2) *Stone*
Prehistoric artists painted directly on stone (see color plate 5, p. 19). Later, stone generally served as a support for grounds of either finely chopped straw thoroughly mixed with gypsum or mortar for fresco painting. (See figs. 6 and 10, pp. 34 and 35 respectively.)

(3) *Wood and its derivatives*
Wood makes an excellent support, as long as it has been treated to resist certain chemical reactions and the attacks of insects. (See fig. 5, p. 34.)

Often, before colors were applied, wood supports

were covered with cloth or given grounds of varying thicknesses. (See fig. 2, p. 33.)

Today the use of plywood obviates some of the major disadvantages of wood, particularly the shrinkage and splitting that result from warping. Similarly, once it has received the appropriate ground or priming coat, hardboard is a practical alternative. Pasteboard, even in its raw, untreated state, is often used for sketches; Toulouse-Lautrec made use of it to great effect. (See fig. 4, p. 33.)

(4) *Canvas*

Since the 16th century, when it supplanted the wood panel, canvas has been the support most commonly used by painters. Always even in texture, i.e. without raised lumps, it is coated on one side with a preparation designed to preserve the fabric from the injurious effects of certain substances used in the manufacture of oil colors. It is also treated to be absorbent (like pasteboard), semi-absorbent, or non-absorbent. According to your needs, you may choose either a fine or a coarse canvas.

PREPARING THE GROUND

Commercially produced papers, whether for drawing, wash, or watercolor, have been treated to serve perfectly the purpose for which they are intended. However, in certain cases, it may be beneficial to modify the qualities of the paper.

MAKING A PAPER NON-ABSORBENT

To render a paper less absorbent, 'prepare' it by covering the working side either with a very light coat of linseed oil thinned with turpentine, or with an egg yolk-based solution. In either case the drying time of the paint will increase.

THE TOOLS

(1) *Colors:* In schools the most commonly used colors are water-based: watercolors, gouache, tempera, and Indian inks. They come either in tubes or in small cakes. (See figs. 8 and 9 respectively, p. 35.) It is only through practical experience that you can get a clear idea of the relative advantages and disadvantages of each. When choosing among different brand names, it is best to consult your teacher or artist's supplier for advice on the quality of each product.

(2) *Hair brushes:* A hair brush is an instrument for spreading colors, varnish, glue, etc.; it consists of a pointed bundle of badger or polecat or other animal hair, affixed to a long, narrow, wooden handle.

> (a) A wash brush is a very full brush tapering sharply to a point and capable of carrying a considerable reservoir of paint.
>
> (b) A fresco brush is a brush whose hair is resistant to lime and arranged in a fan shape.

(3) *Bristle brushes:* A bristle brush is an instrument for painting, whose flags or bristles are short and straight. (See fig. 19, p. 42.) In general the flags of a bristle brush are less supple than their hair or sable equivalents; consequently, they are not used for the same purpose. It helps therefore to have access to a small bristle brush in addition to the sable brushes generally supplied with the paintbox.

(4) *Painting knives:* A painting knife is an instrument for spreading, flattening, and smoothing colors. It consists of a pliable steel spatula attached to a handle. Painting knives come in numerous shapes and sizes. (See fig. 21, p. 42.)

(5) *Rollers:* The roller derives from the printer's ink roller. It consists of a cylinder of color-absorbent material which revolves on an axle fixed to a handle. As it is rolled along a surface, it rapidly lays an even, regular layer of paint.

(6) *The palette:* A painter's palette is a flat, elongated object with a hole for the thumb to stick through. Paints are arranged and mixed on the palette.

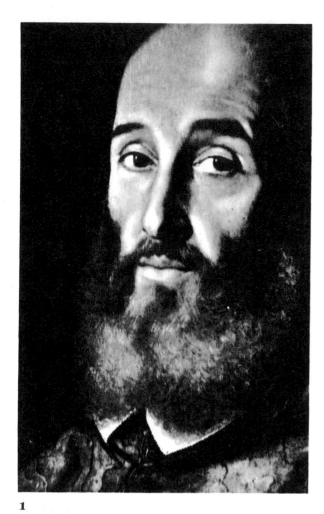

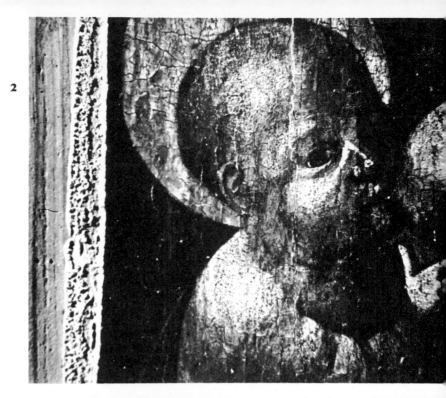

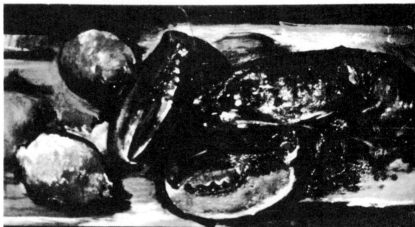

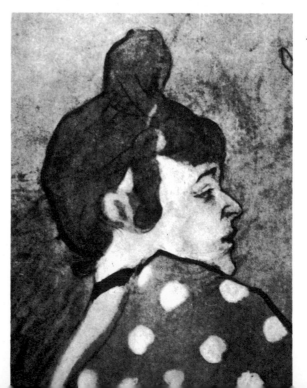

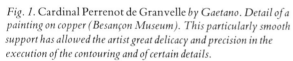

Fig. 1. Cardinal Perrenot de Granvelle *by Gaetano. Detail of a painting on copper (Besançon Museum). This particularly smooth support has allowed the artist great delicacy and precision in the execution of the contouring and of certain details.*

Fig. 2. Painting on panel (Besançon Museum). The wood panel was covered first with cloth (not visible here), then with a thick, solid ground coat (visible on the left edge of the photograph). Finally, after receiving another finer coating, the surface to be painted was rubbed smooth. In spite of all these precautions, the wood has warped and even split. (There is a visible crack running from the eye to the top of the skull of the infant Christ.)

Fig. 3. The blue lobster *by Girard. This was done in egg-based paints on plywood covered with a light ground coat of whiting and glue (casein). Tempera's rapid drying qualities make it possible to superimpose colors without mixing them and to obtain in a very short space of time effects similar to those of oil painting. This still life was painted almost entirely by hand. The fatty matter of the egg facilitates the contouring, binds the colors to each other, gives them depth, and removes all impression of dryness.*

Fig. 4. Detail of a painting on pasteboard by Toulouse-Lautrec. Lautrec often used this material because its absorbency permits rapid execution.

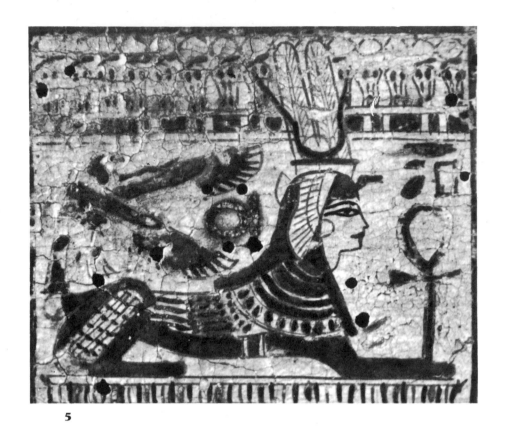

5

6

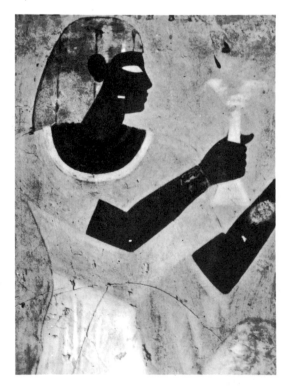

Fig. 5. Detail of a sarcophagus (Besançon Museum). The Egyptian artist painted on to a ground a very thin coating which adhered firmly to the cedarwood of the sarcophagus. The painting was preserved and consolidated with varnish. The holes bored in the wood by insects are visible in this detail.

Fig. 6. Egyptian painting. The Egyptians painted in tempera on a finely pounced ground, consisting generally of stucco or a loam of fine straw and plaster, which was applied to the stone or rough brick wall. A painting technique of great fragility but particularly suited to decorating the interiors of tombs.

7

9

Fig. 7. The ingenuity of man lends him to use supports which are often unusual or unexpected; for instance, this eucalyptus bark painted by an Australian aborigine.

Fig. 10. Fresco by Girard. In order to reproduce the material difference between the hair and the face, as well as the difference in luminosity, fresh mortar was firmly pressed and smoothed with a trowel while the face was being laid in position, so that the texture of the skin would appear tighter and finer.

10

8

4. The art and technique of painting

THE AIMS OF PAINTING

(1) A painting can aim to please through a harmony of colors judiciously chosen and arranged.

The first aim of painting is to harmonize one color with another for the pleasure of the eye.

'The principal merit of a picture is that it should be a feast for the eye.' (Delacroix.)

(2) Painting arouses in us visual sensations which are rapidly transformed into emotions. Certain colors, certain harmonies evoke sadness, joy, gentleness, violence, tenderness. The artist should therefore choose those colors from his palette which are best suited to express in aesthetic terms the feelings he is experiencing and which he wishes to impart to his work.

The second aim of painting is to achieve harmony between the colors selected and the aesthetic expression of the subject matter. Color, line, form, material, and effect must all unite in a single aesthetic expression.

(3) Thus intimately linking with design, form, and material, color is able to augment the degree of resemblance between the painting and that which inspired it.

The third aim of painting, then, is to recreate a color harmony consistent with reality or a 'possible reality'.

Three principal types of color harmony can therefore be distinguished:

(a) Pure harmony, in which beauty of color is sought for its own sake.

(b) Appropriate harmony or expressive harmony, i.e. color harmony consonant with the general aesthetic expression of the subject in hand.

(c) Harmony of the real, in which the color harmony is closely modelled on nature.

PAINTING AND THE PAINTER

A painter may think and dream 'in color', but he comes up against material and technical difficulties once he has to make his vision concrete. It is by painting that the artist discovers the technique that suits him best. But a painter attempting to discover his own style and his own direction should have at his command an elementary knowledge of basic techniques.

It is reasonable to begin your apprenticeship as a painter by studying and practising the technical means which will enable you to translate a real and visible model accurately into a painting. No one can express himself freely who does not know how to express himself clearly; every insufficiency of technique is an obstacle to freedom of expression. You should not be surprised therefore to discover that all the great artists, however avant-garde, knew their trade from top to bottom and knew, in the minutest detail, how to 'create a resemblance'.

General comments on aqueous media

WATERCOLOR

Watercolor is a form of water-based painting whose essential quality is transparency. None of the watercolor pigments contains any white, but all of them can be lightened by heavy dilution with water because, due to their quality of transparency, the paper ground acts as a white.

WASH (INDIAN INKS)

Indian inks, black or colored, possess the same qualities as watercolor, with the additional quality of permanence.

GOUACHE

Gouache is an aqueous paint which may contain white and which is more opaque than watercolors. Gouache can sometimes be applied quite thickly (although if used too thickly it tends to crack, despite the fact that it contains a fairly elastic binding agent, glycerine). It can also be used in very thin washes (gouache heavily diluted with water), but these never have the transparency and luminosity of watercolors.

TEMPERA

Tempera is a type of gouache to which a little egg yolk has been added.

FRESCO

Fresco is aqueous painting on wet lime plaster. The artist works on a ground of freshly laid plaster, using brushes whose bristles are either made of lime-resistant material or arranged in a fan shape. The pigments employed are water-soluble powders resistant to both lime and cement. A fresco must be completed in the time it takes for the mortar to 'set', i.e. to become hard (between four and twelve hours depending on the weather, the time of year, and the climate).

Watercolor, wash

MATERIALS
 Watercolor paper
 Wash brushes
 Two pots of water (one for washing the brush, the other for rinsing and as a reserve of clean water)
 A small sponge

APPLYING A FLAT COLOR WASH

Place the quantity of Indian ink required to obtain the desired tint in a pot containing a few drops of water; if necessary, add more water or ink to the resultant mixture.

Moisten the surface to be painted. (See fig. 1, p. 38.) Apply the tint with a wash brush using a backwards and forwards motion. Avoid going over the same spot too many times in succession.

Tilt the sheet of paper slightly so that the color accumulates in the lower part of the trace left by the preceding brushstroke. (See fig. 3, p. 38.) Continue to work the color-charged brush steadily down the paper. Take more color from the pot whenever necessary, so that there is always a small reserve at the bottom of the completed part of the exercise. Do not, however, allow the reservoir to become so heavy that it runs. (See fig. 4, p. 38.)

When you reach the bottom of the surface to be covered, mop up the excess of liquid color with a dry brush.

Note: Watercolor is handled in the same way as wash.

Advice: Use good quality papers to avoid 'cockling' through the action of water. Professionals use drawing boards on which they stretch moistened paper. As it dries, the paper pulp shrinks, and the sheet becomes taut. It can then be worked on under ideal conditions.

Never gum a paper on which you intend to apply a wash. A speck of gum removes the prepared surface of the paper, which then becomes spongier, and consequently absorbs a greater quantity of the coloring material, resulting in a stain.

If you wish to moisten a sheet of paper on one side only, you should firmly anchor it to your portfolio cover with metal clips to avoid curling.

Gouache, tempera

Unlike watercolors, gouache and tempera (and oil paint) can be applied thickly in the form of a more or less fluid paste. But a long-haired, pointed sable brush is far from ideal for handling, spreading, and working this paste. Instead, you should use a bristle brush, your fingers, or a painting knife. (See figs. 19, 20, and 21 respectively, on p. 42.)

You can also add to gouache a little glue, fine sand, or any other material, as long as these foreign bodies do not alter the essential qualities of the medium (i.e. as

long as the color retains its pliancy and does not crack).

PRACTICAL AIMS

(1) *To investigate the specific qualities of a material.* (The model to be examined is the bark of a tree covered with patches of dry moss.)

Use a sheet of thick, grained paper, or better still, cardboard. Prepare a very thick ground consisting of a little glue of the type used for tinted papers, and water. Spread some of the ground coat on that portion of the paper or cardboard on which you are going to represent the bark. Match the color of the paste to the general color of the bark, and at the same time contour it with your finger to give a fairly accurate reproduction of the main relief areas of the model. Try experimenting in places with the lumps and granules produced by imperfectly dissolved glue. Use the pointed end of a paintbrush handle to simulate the fissures, the crevices, and the holes made by insects. Wait until the ground coat is dry enough to take pressure without being squashed out of shape, and then add the superficial details and the dry moss effects with your fingers, using a light touch.

Keep only the sections that turn out successfully, and try to copy them accurately in order to familiarize yourself with this technique of controlled impasto.

(2) *To discover the effects and the specific qualities of painting on an absorbent ground.*

(The model to be copied is an Egyptian painting on plaster and loam ground.)

Use a fairly strong, grained paper. Prepare a ground of glue, gouache, and whiting (or alternatively, plaster or very fine sand). Spread this coat with a roller or a large, supple brush to form a solid, homogeneous layer about $\frac{1}{24}$ in. (1 mm.) thick. When dry, trace the main outlines of the model on to it. For painting use fairly fluid colors. (The ground absorbs water like a sponge.) Use the point of a knife to simulate the cracks in the painting, and to reproduce the spots where the painting has chipped away remove some of the ground. Finally, try to reproduce all the effects of color deterioration due to the passage of time, climate, and maltreatment by scraping down to the bare ground. The general effect will be very mat.

Note: While painting, take care not to dissolve the base layers. Do not, therefore, pass a saturated brush more than once or twice in succession over the same spot. For greater accuracy, make the grounding either broken white or the color of stone or mortar.

(3) *To obtain a shiny or satiny material.*

(The objective here is to make a design for a stained glass window, a mosaic, a piece of lacquerwork, or marquetry.)

Use a heavy, fine-grained paper. To make gouache shiny, you only need to coat it with a special varnish when it is completely dry.

To obtain shiny or satiny effects, you can also use tempera paints made with wax emulsions. When they are dry, rub them with a wool rag.

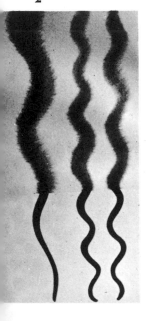

1

2

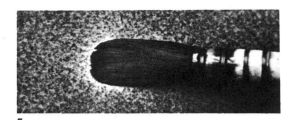

5

6

7

3

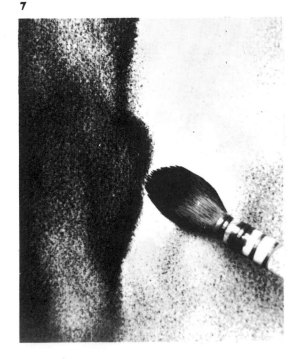

4

Fig. 1. Effects of a drop of ink (or liquid color) falling on a sheet of moist paper.

Fig. 2. On a dry (absorbent) ground, brushstrokes have clean, precise, clearly defined edges. On wet (or very moist) paper, the color spreads. It loses in concentration what it gains in spread. The contours are soft and imprecisely delineated.
To spread the color evenly, employ a backwards and forwards motion, taking care at each stroke to direct the handle of the brush in the direction in which you intend to go.

Fig. 3. The sheet of paper has been inclined so that the color drawn by the brush flows smoothly and steadily towards the trailing edge of the surface to be painted. The reserve of liquid prevents the color from drying too rapidly, and allows each brushstroke to merge with the preceding one.

Fig. 4. The sheet of paper was inclined too sharply, and the color has run. An excess of material (a brush saturated too heavily with liquid color) can have the same annoying consequences.
Finally, a dry brush is used to soak up the excess of liquid from the lower edge of the painted area. With experience, it is easy to match its value to the rest.

Fig. 5. Laid flat on paper that is still wet, a half-dry brush absorbs a little of the color and slightly lightens the tint.

Fig. 6. Here color has just been applied to a moist paper ground. To lighten a given area, go over it with a carefully rinsed and dried sable brush. The dry hairs draw up some of the color, which then appears lighter as more of the white of the paper shows through.
To restore the white ground of the paper as much as possible, flood with a brush the area you want to lighten; then use the dry brush technique. Repeat the cycle as often as necessary.

Fig. 7. You can contour an originally flat tint by lightening some areas (using the method outlined above) and darkening others with additional applications of the brush saturated with coloring matter. The figure shows a sketch of a tree trunk. The lightened and darkened areas are clearly visible.
You can give more definition to the contour of the trunk by absorbing the small particles of coloring matter which have spread a little too far as a result of pre-moistening the paper. Use a well-dried sable brush, and squeeze the hairs flat between two fingers. The small amount of pigment that remains conveys aptly the rough and rugged appearance of the bark and the dry mosses.

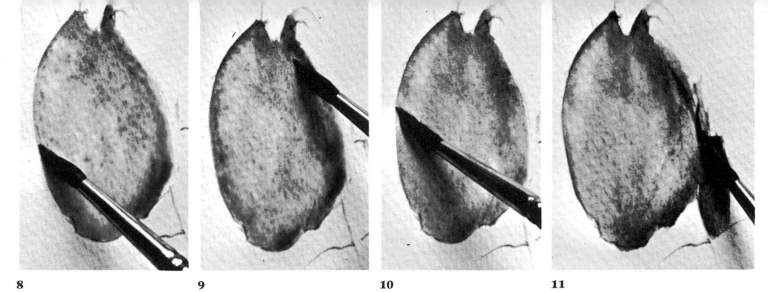

8　　　　　　　　　**9**　　　　　　　　　**10**　　　　　　　　　**11**

Fig. 8. A base tint has been laid on moistened paper.

12

Fig. 9. A second application of color reinforces weak areas.

Fig. 10. A dry brush is drawn over the areas to be lightened.

Fig. 11. It is best to wait until the paper is almost or completely dry before working on areas or lines whose contours have to be relatively clear-cut. In fact, color 'takes' well on dry paper and tends not to spread beyond the area covered by the brushstroke.

Fig. 12. A reproduction of a work by Manet. Try to reproduce the varying degrees of transparency on wet, half-dry, or dry paper.

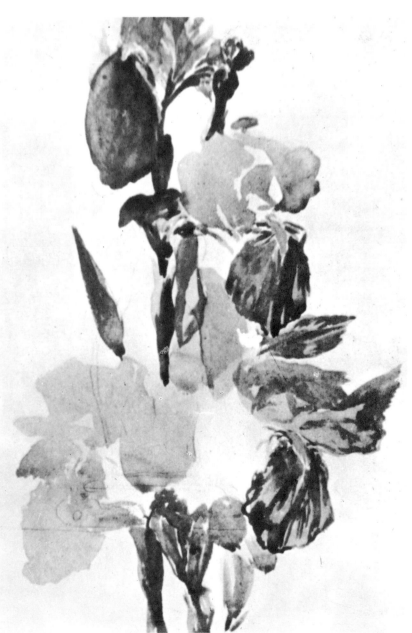

13 14 15 16 17

18

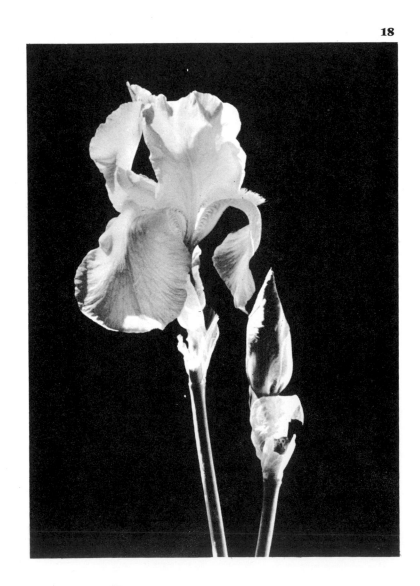

(4) *To increase the drying time of gouache slightly.*

(The method to be employed is to mix a solution of water, which is used to dilute the color.)

You already know that egg yolk is very rich in fatty matter and that it is soluble in water. It also retards the drying of any color to which it is added, thereby facilitating contouring and detailed work. Testing this process at least once is strongly recommended, in order to familiarize yourself with its numerous advantages.

Each type of painting has its advantages and its drawbacks: watercolor is luminous and transparent, but once dry it is difficult to retouch. Gouache, because of its opacity, can be retouched, but it dries very quickly, which makes it unsuitable for large-scale work. Artists have always searched for colors which dry slowly and thereby give them more time for contouring and attention to detail. Their discoveries have included the wax (or more precisely encaustic) paint used by the Greeks and Romans; the egg yolk technique of tempera, producing works which, when varnished, had the appearance of oil paintings; and the richest, the most flexible technique of all, painting in oils.

(5) *To discover the effects of painting knives and spatulas.*

Spread some color with a small painting knife or a piece of wood cut to a feather edge and rubbed smooth with sandpaper. Manipulate these implements and the colors freely at first to familiarize yourself with them before attempting to reproduce the attractive effects in paintings by Vlaminck, for example. (See color plate 3, p. 20.)

A bristle brush (a paintbrush whose bristles are for the most part mounted flat and which culminate in a straight line rather than a point) will enable you to spread a broad wash of color more easily and swiftly than a hair brush.

Opposite:

How to correct contouring mistakes and errors in value.
Fig. 13. A mistake has been made: in the upper portion of the subject the color is too dark.

Fig. 14. This can be remedied by diluting the spot with water (using a brush previously rinsed and dipped in clean water) before it has had time to dry. The areas to be lightened are then worked with a dried (i.e. dry or almost dry) brush.

Fig. 15. The same mistake has been made in the lower part of the subject.

Fig. 16. The remedy is the same: the dark spot has been quickly diluted with water and then worked with a more or less dry brush.

Fig. 17. All accents and sharp-edged lines are added on dry paper with the tip of a brush saturated with concentrated color.

Fig. 18. Photograph of an iris flower and bud. Try to reproduce accurately the different grey values on very fine grain (or even toothless) watercolor paper. Try to convey both the soft and the hard-edged effects of different areas.

Carry out the same exercise on black paper using white gouache diluted with varying amounts of water.

D

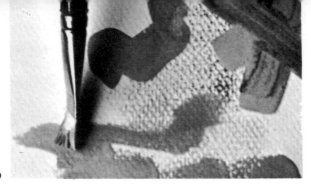

19

20

Fig. 19. *Saturated with varying amounts of color and dexterously employed, a bristle brush allows a wide diversity of brushstrokes ranging from the lightest to the heaviest impasto, from blended passages (the result of superimposition of one kind or another) to the boldest of lines with crisp and clearly defined edges.*

Fig. 20. *A similar effect to very light brushstrokes (see fig. 22) can be achieved by rubbing a little color very gently with your finger on to the working surface. You can produce perfect uniform grounds quickly with a roller.*

Fig. 21. *The painting knife. Flattened and smoothed by the metal blade of the painting knife, colors take on a polished aspect which reflects light and results in a deeper and livelier tone. (See color plate 3, p. 20.)*

Fig. 22. *If you use a small quantity of color, or color that is barely moist, a flat short-haired bristle brush drawn almost horizontally across the surface of the paper or canvas can produce very light brushstrokes.*

21

Opposite:

Fig. 23. *Flowers (detail) by Dufy. This painting is an example of the combined use of hair and bristle brushes. In some areas the bristle brush has worked on the material in depth, uniting and blending one color with another; in others the flexible tip of the hair brush has traced out, on the dry or half-dry ground, lines or small spots with clear, precise edges. The combination of the fluidity and flexibility of some brushstrokes, and the nervous precision of other more clearly defined lines, recreates and accentuates the essential plastic and aesthetic qualities of the flowers, leaves, and stalks (lightness, delicacy, fragility, mobility, elegance, and a nervous suppleness), not to mention the splendour of the colors and the richness of their shading.*

Fig. 24. *Portrait of Madame J. Guillemet (detail) by Manet. This was executed in pastel on canvas. By rubbing and crushing the powdery material of the pastel under his finger, Manet obtained blended passages of great fluidity, particularly in the contouring of the face. In other places the line is either more prominent (the wisps of hair) or positively clear-cut (the delineation of the clothing). Finally, by laying the pastel flat and gently rubbing it on the canvas so that the dust was deposited only on the raised part of the grain, Manet reproduced the relatively coarse texture of the cloth, which highlights, through contrast, the sweetness and delicacy of the face.*

Fig. 25. Brown fir tree *by Klee. This painting uses the rubbing technique with watercolors.*

Fig. 26. Moon behind clouds *by Ganku (18th century). This is a remarkable example of blended passages which combine lightness and transparency.*

22

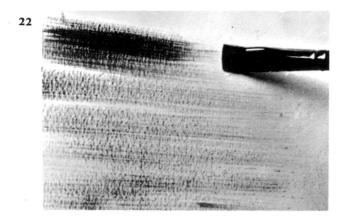

23

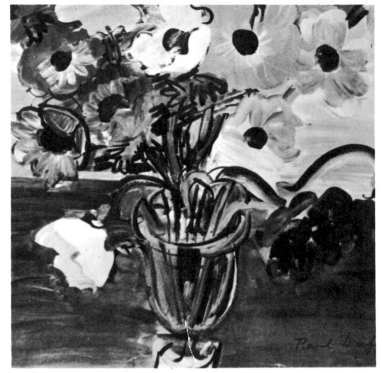

24

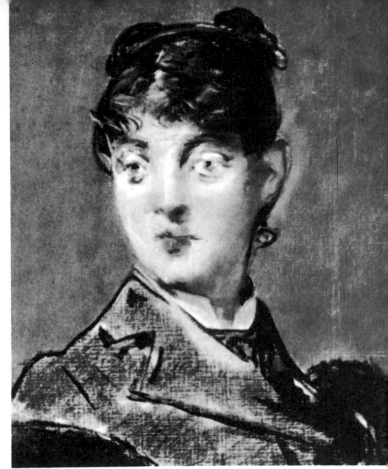

25

26

5. Decorative composition

To compose is to arrange different elements in a given scale and format in such a way as to constitute a whole with its own unity, its own harmony, its own purpose, and its own beauty.

THE PRINCIPAL ELEMENTS OF A WORK OF ART

The principal elements in the composition of a work of art are, on the one hand, its creator (his temperament, eye, mind, aesthetic sensibilities) and, on the other, the forms, materials, lines, and colors that he employs.

Anyone embarking upon the composition of a work of art should take into account not only the nature of the support on which it is to be executed, the materials to be used, the scale, and the format, but also the practical and aesthetic aims of the work, and its ultimate destination. All these different elements and heterogeneous factors must be united and harmonized.

COMPOSITION AND ITS GENERAL CRITERIA

Certain rules of composition and certain criteria are applicable to all works of art, whatever their genre.

A work of art should be composed in such a way that it is in perfect accord with the forms, the format, the aesthetic character, the aim, and the ultimate destination of the subject from which it draws its inspiration or to which it refers. Furthermore, it should respect the specific qualities and limitations of the technique or artistic framework selected for its execution.

In order to simplify matters initially, this chapter will be limited to the analyses of decorative composition.

To decorate is to embellish, while retaining a certain utilitarian or practical character in the work. For example, you can decorate or embellish a concrete floor, but only so long as its flatness, solidity, and resistance to wear are respected.

(1) *Decoration and the form to be decorated*
Suppose an artist has to decorate a vase whose basic form is the outcome of much careful study by a master potter. A good decorative artist will do his best to work out a decorative scheme which will emphasize the aesthetic qualities of the particular vase, so that to the beauty of the basic object will be added that of formally appropriate decoration.

A bad decorative artist, on the other hand, might perhaps choose a design which he would consider good for no other reason than that it pleased him, and which he would have thought up without having taken the least account of the particular aesthetic character that the master potter had given to the form of his work.

(2) *Decoration and format*
The decoration should adapt itself to the format (square, rectangular, oval, round, etc.) of the object to be decorated, either to emphasize its aesthetic character or, if necessary, to minimize its defects.

(3) *Decoration and the scale of the object to be decorated*
The decoration should be scaled to the object to be decorated; it should be finer and more detailed for a piece of goldwork or lace, for instance, than for an architectural motif.

(4) *Decoration, its destination and purpose*
A decoration should match precisely the situation and purpose for which it is destined. For example, you would hardly use the same color harmony or the same interplay of lines and forms for a hospital room as for a ballroom.

(5) *Aesthetic harmony of decoration and object*
A good decorative artist knows how to emphasize the character he wishes to give to his work. Right from the first sketch, he knows what the dominant aesthetic quality will be. Confronted with a work whose aesthetic character is clearly and easily understood, the viewer does not need to ask questions on the subject; he can freely and effortlessly enjoy all the qualities of the work.

(6) *Materials and technique of decoration*
Each material has its specific qualities and deficiencies, and each craft requires a specific technique. You would be ill-advised to execute with materials of one type, and in the technique appropriate to those materials, a work whose qualities warrant other materials and another technique.

For example, the essential qualities of oil painting are flexibility, density, transparency, and the possibility of copying nature precisely; the qualities of tapestry are entirely different. There would be little point in using colored wool and silk thread to produce effects which can easily and rapidly be achieved in painting. The result would possess neither the qualities of tapestry nor those specific to oil painting, and would therefore be lacking in character.

(7) *Aesthetic variation according to materials*
The aesthetic character of decoration varies with the materials used. It is obvious that something made in wrought iron would not possess the same characteristics of fineness and delicacy as a piece of lacquerwork.

All the criteria above can be summarized in three basic statements:

(1) *Suitability*

All decoration should perfectly match the subject to be decorated, i.e. it should enhance its plastic and aesthetic qualities.

(2) *Simplicity*

All decorative composition should unequivocally affirm the purity and simplicity of its aesthetic character.

(3) *Unity*

The decoration should form a single entity with the object to be decorated.

These criteria support Raoul Dufy's statement that 'Every work of art is complete in itself'.

6. Composition in nature

Every order, species, genre, class, and family has specific characteristics. By virtue of these shared characteristics each species is unique. Yet no family, however prolific, produces two absolutely identical individuals or elements. Either they will differ in coloring, size, disposition, or age, or else they will have developed in different terrains and under different climates and conditions. Nature is synonymous with variety. It entirely lacks the fixed and immutable character of the 'prefabricated'; it evolves, it is in a constant state of transformation, it moves; in a word, it is alive.

A significant proportion of this book is devoted to the study of the principal modes of composition in nature, in the belief that our imagination can thereby be guided towards new and original forms of expression.

SYMMETRY
Absolute symmetry does not exist in nature. Man, however, apparently has a need for symmetry, since he employs it in almost all his creations: utilitarian objects, furniture, fittings, etc. (See fig. 5.)

AESTHETICS
In a body composed of two symmetrical halves, each of them when reversed is the exact replica of the other. The result is that the effects produced on our thought processes by the sight of the two symmetrical halves are exactly identical; the thought process does not undergo any change, any modification, as one switches from examining one part to examining the other. Symmetry lulls thought to sleep instead of animating it, which is why symmetry is favoured by the arts which put the pleasure of the eye before all else (the decorative arts) and not by those which aim at the expression of feelings and thoughts (the fine arts).

ANALOGY AND IMAGINATION
An analogy is a resemblance between two things, two creatures, or a creature and a thing: a resemblance of form, function, size, etc.

An imaginative artist finds analogies where most would see only differences. By recognizing analogies, imagination permits the artist to pass easily from one form to another analogous form, from one function to another function and, in consequence, to transform one reality into another reality; in a word, to compose and to create something new.

Analogy facilitates the classification of individuals with shared characteristics; it facilitates the vision and classification of the world.

THE LOGIC OF NATURAL FORMS
Throughout the natural world there is a correspondence between form and function. In the following examples you will see that the form of any organism, far from being arbitrary, is directly related to the life processes and conditions of that organism.

NATURAL FORMS IN WORKS OF ART
Each of nature's infinite combinations of forms, lines, and colors can be a source of inspiration for the artist.

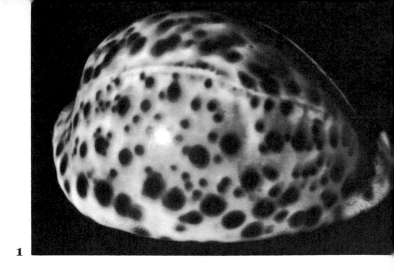

1

2

3

4

Fig. 1. Cowrie. The decorative unity of this shell is based on spots which appear similar, yet no two spots match up exactly.

Fig. 2. Tapestry (detail). Notwithstanding its essential unity, this tapestry ground is enriched with vegetation in a variety of shapes, sizes, values, and colors. In short, the vegetation constitutes its main decorative element.

Fig. 3. Blades of grass seen against the light. In all the vegetation in the world you will not find two blades of grass, two leaves, or two flowers that are absolutely identical.

Fig. 4. Earth-century by G. Claisse. If the circles were given the same centre in the middle of the rectangle, all the animation that dissymmetry brings to this composition would be destroyed.

5

Fig. 5. Mexican tone drum.

Fig. 6. Bracelet. *The dissymmetry of the variously distributed spaces in each of the segments of this bracelet imparts to the whole a sense of movement.*

Figs. 7 and 8. *There is a certain similarity between the shapes of the cactus stem (fig. 7) and the flail (fig. 8) corresponding to an analogy in what these two things express, namely danger and aggression.*

6

7　　**8**

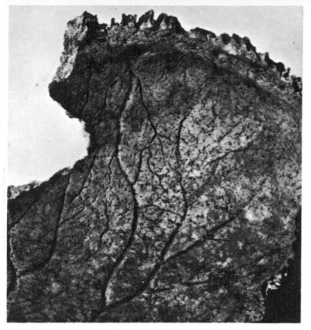

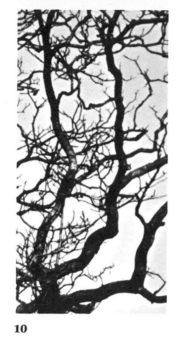

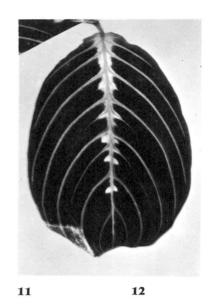

9 **10** **11** **12**

Figs. 9 and 10. The branches of a tree (here a walnut) distribute the sap. The impressions left on the inside of the cranium by the blood vessels supplying the brain provide a curious analogy with the branches of the walnut tree.

Fig. 11. The nerves of this leaf are like a skeleton, complete with thorax, sternum, and ribs.

Fig. 12. This section of the stem of a horsetail, with its fluting and its patina, is reminiscent of a column.

Fig. 13. Iris petal or the fur of a member of the cat family?

Fig. 14. Korean tiger.

Fig. 15. Domestic cat.

13

14

15

16

Fig. 16. Fruit of the horse-chestnut. The almost spherical green seed pod of the horse-chestnut is composed of three sections joined along lines of separation as shown in fig. 18.

Why is this seed divided into three compartments when a pea pod, for example, consists of only two halves?

Figs. 16 and 17. Having reached maturity, the seed (in this case the horse-chestnut) can escape only if its shell opens sufficiently to allow it to pass. This is easy if the pod splits into three sections which fall away from each other; it would be impossible if the shell consisted of only two hemispheres. If that were the case, by virtue of the dissymmetry which reigns in nature, one of the hemispheres would be more developed than the other, and would hold the chestnut prisoner like the jaws of a pair of pincers. (See fig. 18.)

Fig. 19. Although it consists of only two parts, a pea pod can release its seeds easily when they have reached maturity. The relationship between the diameter of a dry pea and the length of the pod that contains it is such that the aperture, which forms in the pod as it dries, is quite sufficient to let the seeds through as they detach themselves.

Since the one does not have the same general form as the other, it would be useless for a pea pod to be constructed in the same way as a horse-chestnut shell. (Note the arrangement of the three lines of separation in the tripartite seed case of the horse-chestnut.) Could the horse-chestnut shed its shell if the latter had all three lines of separation in just one hemisphere, as shown in fig. 18?

17

18

19

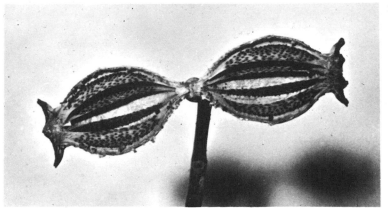

20

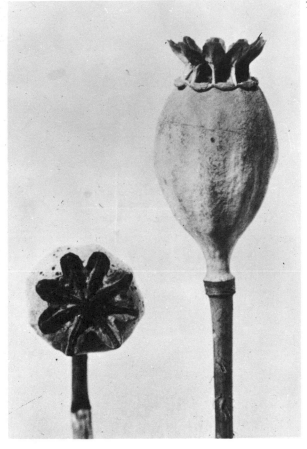

21

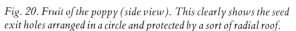

22

23

Fig. 20. Fruit of the poppy (side view). This clearly shows the seed exit holes arranged in a circle and protected by a sort of radial roof.

Fig. 21. Longitudinal section showing the seeds in their exit passages (seed chambers).

Fig. 22. Cross-section showing the radial arrangement of the seed chamber walls. As it bends with the wind, the poppy head casts its seeds all round.

Fig. 23. A spray top from a washing machine. A special system forces hot soapy water to flow up the pipe and out through exit holes (similar to those on the poppy head) in radial jets which cover the entire surface presented by the clothes to be washed. Note the similarity of form between the spray top and the poppy seed case in fig. 24.

24

25

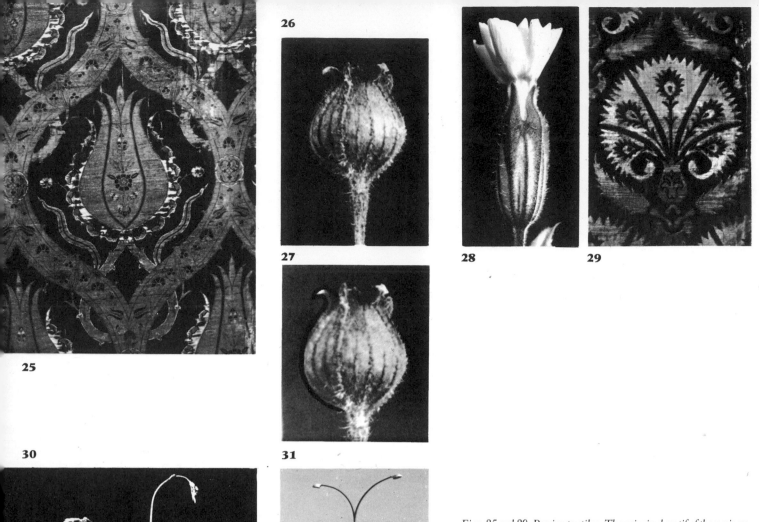

26

27

28　　**29**

30

31

Figs. 25 and 29. Persian textiles. The principal motif of these pieces of cloth, although Persian in origin, shows a certain similarity with small flowers (figs. 26 and 28) which grow in the meadows and on the roadsides of France.

Fig. 30. The elegance of these sprigs of lavender, with their inflorescence at the very tip of a more or less curved arm, could have inspired the designers of the lamp standards (fig. 31) which flank the Autoroute du Sud in France.

Figs. 32 and 33. Woodcarving in the form of a shell.

Fig. 34. Shell-inspired motifs decorate the base of this lamp standard on the Pont Alexandre III in Paris.

32　　**33**　　**34**

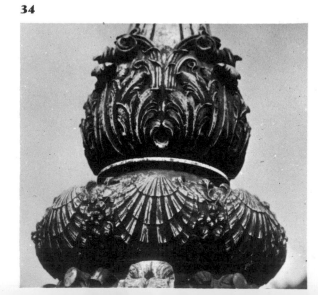

7. Rhythms

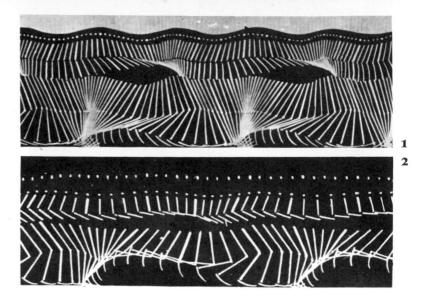

Figs. 1 and 2. An athlete was dressed in a black leotard on which Jules Marey painted phosphorescent dots and bands to indicate the head, the shoulder, the arm, the forearm, the thigh, the knee, the leg, and the foot. The athlete then walked (fig. 1) or ran (fig. 2) in front of Marey's apparatus which recorded the successive positions of the different parts of the body at regular intervals. The cadence and rhythm of walking are perfectly evident in these photographic documents.

A rhythm is a measured and regulated movement; a return, at regular intervals, of the same elements or groups of elements.

RHYTHMS AND LIVING FORMS
Living forms develop and move in accordance with the rhythms proper to their nature and their functions. There is, therefore, an intimate relationship between rhythms and the matter which they animate. For the artist, rhythms represent the vital force which sustains a work of art.

RHYTHMS AND ART
In art, rhythms are alternations and measured cadences applied to forms, colors, values, materials, and lines.

In a creative composition the rhythms are chosen, apportioned, and developed in such a way as to unify the form of the work.

RHYTHMIC UNITY IN NATURE
Every living body is complete in itself. It is therefore a unity. The unity of a living body is manifested in its harmony. Its external manifestations take the form of a unity and a harmony of rhythm.

Despite the fact that, as they repeat their sequences, they undergo small changes of position, proportion, and scale, the rhythms of a living form always preserve their unity of character.

DISCOVERING LINEAR RHYTHMS
The different contours, profiles, and sections of a form can be represented in linear terms. There are three basic types of linear rhythm (rhythms capable of being represented by a pattern of lines).

(1) *Broken straight rhythms* are rhythms composed exclusively of straight lines forming angles and recurring in a certain sequential cadence.

(2) *Curved straight rhythms* are rhythms based on a straight line which leads into a curve; this curve can be an arc, a parabola, a spiral, or any other curve.

(3) *Curved rhythms* are linear rhythms formed by the association of two or more curved lines which recur in a certain sequential cadence.

Using an apparatus that he designed, and which has close links with the origins of cinematography, Jules Marey produced some very interesting negatives depicting movement and its rhythms.

Exercises: Closely observe animals, and try to analyse the rhythm of their forms. Draw them taking particular care to preserve the integrity of their rhythmic unity.

Draw an antique vase by sight; trace the linear rhythm of its outline and, bearing this rhythm in mind, imagine all the forms and sizes of handles it could have.

Carefully study the profiles of those sitting next to you. Compare the character of the rhythm you find in each of them with that of its owner's fingers. Carry out a similar analysis of the rhythms in the work of sculptors such as Michelangelo, as well as in works of decorative art.

3

4

5

Fig. 3. The rhythm of this adolescent face is a succession of straight lines, slightly swelling curves, and flattish areas (the tip of the nose and parts of the lips, for example). It comes as no surprise that these characteristic linear rhythms are to be found throughout the whole body; here specifically in the shape of the end of the middle finger which echoes that of the tip of the nose.

Fig. 5. Seascape by N. Girard-Perdrizet. There is a harmony between the balanced rhythms of the billowing rise and fall of the watery masses and the attenuated rigidity of the solid bodies which the elements cause to revolve around a barely suggested vertical.

Fig. 6. Sculpture by Poncet. The light which caresses these forms polished to a mirror finish, and the images of the objects reflected therein, add their own 'animation' to the rhythms of this work as they join together in perfect unity.

Fig. 7. Projection into space by Pevsner has rhythms as pure as the other projections in space, which were produced by an electric light bulb fixed to the end of an elastic thread and left to etch the darkness with its luminous trajectories. (See fig. 4.)

6

7

Fig. 8. Head of a young dog (side view).

Fig. 9. Tracing of the lower part of the jaw.
 A curved straight rhythm, consisting of a straight line leading into a generous arc, emphasizes simultaneously the tension and the weight of the form.
 Note that the tension, which the inflected straight line of the rhythm heightens, weakens the effect of weight inherent in the arc. The overall result produces an impression of gentleness (total absence of angles), compliant nervousness (transition from straight line to arc), and speed (straight line).

Fig. 10. Turned upside down and manoeuvred into position, the tracing exactly fits the shape of the top and back of the cranium.

Fig. 11. When the tracing is moved over the dog's head, it also coincides perfectly with the upper back part of the ear.

Fig. 13. Alsatian's head (full face). The tracings (fig. 12) demonstrate the clear predominance of broken straight rhythms. Only a few slightly inflected curves mark the passage from one straight segment to the next. The aesthetic expression of this Alsatian's head is clearly different from that of the hound.

14 **15**

16 **17**

18 **19**

20 **21**

Figs. 14 and 16. American and Asian tapirs. At first sight they seem similar; but the former (fig. 14) has a linear rhythm with a curved contour, while the latter (fig. 16) has a curved straight linear rhythm. It would be impossible to exchange the heads, for example, of these two animals without breaking their rhythms. The tracings emphasize the different characters of their rhythms (figs. 15 and 17).

Figs. 18 and 19. The rough tracing (fig. 19) shows the clear predominance of broken straight rhythms in the profile of a wild boar (fig. 18).

Figs. 20 and 21. Grace, nervousness, and agility are characteristic qualities of this deer. These qualities are expressed in two ways: by wide, open, broken straight rhythms which do not have the pointed and aggressive character of those of the Alsatian (fig. 12, p. 55); and by straight parabolic rhythms. The parabola is the line of elegance, suppleness, and relaxed nerves. Note that the facets in the contour of the forehead recur in the contour of the eye.

22

23

24

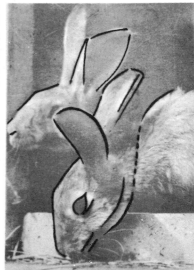

25

Figs. 22 and 24. Heads of domestic rabbits. The heads of the rabbits in fig. 24 show broken straight rhythms. The same type of rhythm can also be seen in the shape of the ears. The head of the white rabbit (fig. 22) shows a predominance of curved rhythms (the rhythm of the forehead, for example); therefore it is not surprising that the tracing of this rabbit's ears reveals forms with more rounded and fewer broken rhythms than those of the rabbits in fig. 24.

Figs. 26 and 27. Head of a kitten. The tracing (fig. 27) shows the harmonious repetition of rhythms based on a short segment of straight line leading at either end into opposing curves. This rhythm typifies rapid movement capable of changing direction in the course of its execution.

Figs. 28 and 29. Picasso's Goat.

Fig. 30. Mosquito with legs either spread-eagled or torn off. An example of forms with broken straight rhythms. The insect is so constituted that its wing-span and its lightness allow it to land unnoticed on its victim. Note the perfect straightness of the separate sections of the legs, the axis of the body, and the axis of the two wings, each section being virtually an extension of the other.

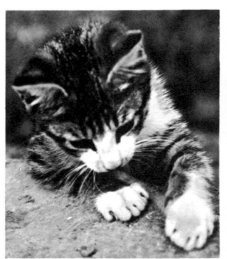

26

27

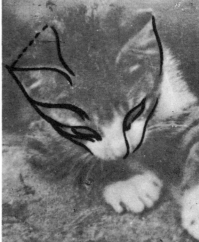

28

29

30

1

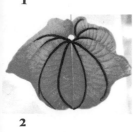

2

3

4

5 6

8. Harmonics

In any living form the essential structural lines which appear to separate or unite the secondary parts of the form are known as 'harmonics'. Harmonics correspond to lines of intent and vital energy. Harmonics and rhythms share characteristics because they are both produced by the same vital energy, thus harmonics can reveal traces left by frequent repetition of gestures or functions appropriate to a form, for example, lines on the hands or facial wrinkles. Harmonics can also be lines marking the different stages of growth of a body, for example, the rings of a tree (fig. 9, p. 59), corresponding to the annual increase in diameter. Harmonics represent the distribution of masses and of the energy which animates them; they are also known as 'lines of partition'.

To sum up, harmonics are those essential structural lines which best adapt themselves to the functional and aesthetic character of a form, while at the same time revealing its mode of formation and growth.

GEOMETRY AND HARMONICS

In geometry, harmonics (or lines of partition) are lines which divide a geometric figure into surface or secondary forms which are perfectly balanced in relation to each other.

In geometry, as in nature, harmonics respect and accentuate the aesthetic character of the form to which they relate. The simpler the geometric form, the simpler its harmonics.

Figs. 1 and 2. The nerves of this leaf distribute the sap so evenly and so harmoniously that there would be no reason to modify its layout. Such nerves, by virtue of their straightforward, simple, and harmonious disposition, could well be called 'harmonics'.

Figs. 3, 4, 5, and 6. Note the satisfying arrangement of the nerves (some more apparent than others), the areas of color, and the raised portions of these two leaves.

Fig. 7. Magnetic field of a dipolar magnet. The lines of force are distributed harmoniously round the two poles.

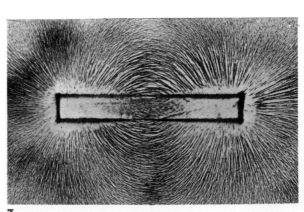

7

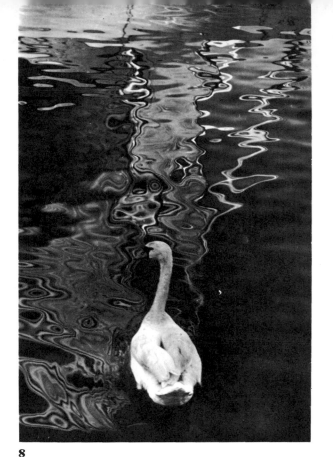

8

9

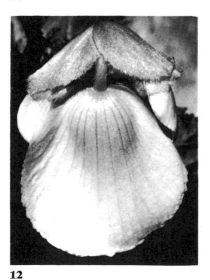

10

11

Fig. 8. Swan on lake. Ripples on the surface of the water combine with a floating iridescent film to create shapes and lines conveying natural harmony and rhythm.

Fig. 9. Cross-section of fruitwood growth rings in a piece of furniture (Musée des Arts Decoratifs, Paris).

Figs. 10 and 11. Every line of growth is the harmonic of a living form.

Figs. 12 and 13. Where they are alike, the respective forms of the shell and the flower have analogous harmonics. The traced outlines emphasize the analogy.

Figs. 14 and 15. Under the influence of gravity, similar forms identically disposed in relation to a vertical axis and with equal opportunity for free development possess analogous harmonics of fall. The tracing underlines this characteristic.

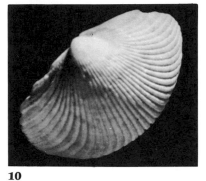

12

13

14

15

9. The natural form

At the origin of every living form is a minute nucleus (cell, seed, etc.) which develops outwards. A form can grow in one direction more than in another, in several different directions, or in every direction at the same time.

Life develops in all directions simultaneously; but the aesthetic character of a form is largely dictated by the lines of force, which dominate every other characteristic. The relative nature of development (a more rapid, more continuous, more powerful thrust in one direction than another) determines not only the character of a form but also its aesthetic quality. An extended rectilinear or curvilinear form does not arouse in us the same aesthetic feeling as an egg-shaped or spherical form.

REPETITION IN NATURE
By repeating itself, nature safeguards the essential characters of each of its species. Repetition is one of the basic concepts that the study of natural forms suggests to us.

REPETITION AND HARMONY
In order to live, forms which repeat themselves within a whole must be harmoniously disposed in relation to each other, in order to occupy the precise space allotted to them and to draw equal benefit from the necessary vital elements. (See figs. 3, 4, and 5.)

1

Fig. 1. Flower with two petals.

Fig. 2. Spider's web. An example of the development of a form in a single plane. Starting with a central nucleus, the spider's web develops along lines determined by radialization, concentricity, and a variable but definite spiral tendency.

Harmoniously joined rectilinear, centripetal, and radial arrangements, together with concentric, spiral, and helicoidal configurations, enable nature to create an infinite variety of different forms and figures.

2

3

5

4

Fig. 6. Wild Boars. *The repetition of similar elements creates an impression of power and dynamism.*

Fig. 7. The four eyes of Dino. *A strangely fascinating impression which a single pair of eyes alone could not convey.*

Fig. 8. A stone has fallen into a stretch of still water. The energy released at the point of impact produces concentric waves of ever-increasing diameters. A circular nucleus in a plane can therefore develop in the form of concentric circles. Concentric circles represent harmonics of the circle. (See pp. 73–75.)

Figs. 9, 10, and 11. A circular nucleus in a plane can develop in the form of straight lines leading from the centre towards the circumference (radial development).
 The diameters of a circle represent harmonics of the circle.

Figs. 12 and 13. The circles which pass through their two poles stand out very clearly on the surfaces of these analogous spherical bodies.
 Circles that pass through the two poles of a sphere and envelop its surface represent harmonics of the sphere.

Fig. 14. Starting from a central nucleus, the form can develop in all directions and assume a spherical appearance. The lines which join the centre of a sphere to every point on its surface represent internal harmonics of the sphere.

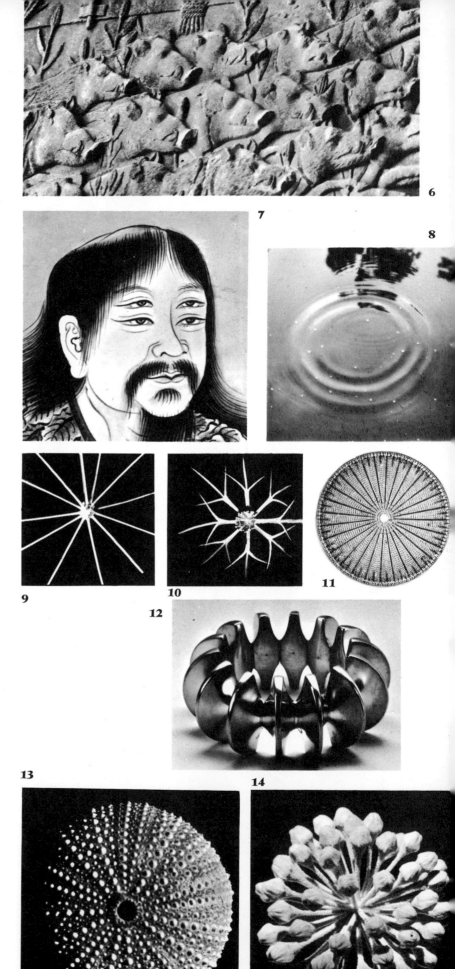

15

16

17

18

Examples of the division of a form by harmonies issuing from a point :

Figs. 15 and 16. Leaves in the form of jets of water, and an architectural motif.

Figs. 17 and 18. A shell.

Figs. 19 and 20. The folds of a garment. (Greek bas-relief, early 4th century B.C.)

Figs. 21 and 22. Leaves with découpage edging and palmate nerves.

Figs. 23 and 24. Umbelliferous plant with fruiting inflorescence.

19

21

22

20

23

24

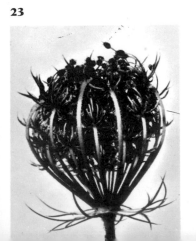

Fig. 25. Fungia from the Philippines. The rectilinear nucleus is very short in relation to the general extent of the form of which it is the core. Continued at either end, it would constitute one of the two axes of symmetry of this fungia, the other perpendicular to it and passing through its centre.

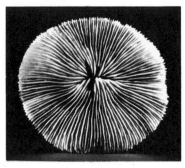

25

27

REPETITION IN ART
The concept of repetition in natural forms is linked in the mind with a feeling of simplicity due to the unity of character of repeated forms, and of richness due to the multiplicity of their component elements.

AESTHETICS
The beauty of repeated elements is emphasized by their multiplicity. This multiplicity adds richness to a work of art.

STUDY OF FORMS WITH A RECTILINEAR NUCLEUS OR AXIS
The harmonics of a form with a rectilinear symmetrical axis establish themselves along the whole length of the axis in such a way as to allow each its vital space.

Observation: Harmonics issuing from the extremities of the nucleus prolong it in a straight line. They constitute the first axis of symmetry. The harmonics of the rectilinear nucleus are perpendicular to it at its centre. They constitute the second axis of symmetry. Between these two axes of symmetry, perpendicular to each other, all the other harmonics are deployed. The shorter the rectilinear nucleus of a form in relation to the overall mass (that is to say, the more it resembles a point), the more the overall mass tends toward the circular.

Fig. 26. Haliglosa echinata. The rectilinear axis is comparatively long in relation to the overall form of the haliglosa. A second axis of symmetry bisects it. The same method of implanting harmonics can be observed here as in the previous illustration. Note, however, that the overall form has developed in length along the axis. The length of the form and the length of the axis are thus harmonized.

Fig. 27. Slightly parted lips. The axis divides the form from end to end throughout its length. In this instance the two lips should be studied separately, since they have neither the same structure nor the same form.

Note, however, that a mouth has a vertical axis of symmetry, even though the harmonics which would extend the horizontal axis do not have room to develop.

28 29

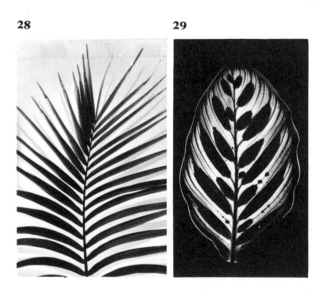 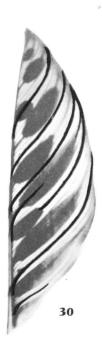

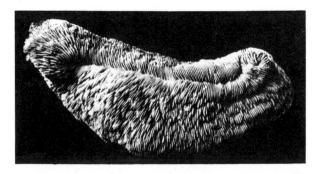

26

Figs. 28, 29, and 30. The axes which divide the forms from end to end represent the only possible axes of symmetry. The harmonics, denoted here by the outlines of the nerves, occur along the entire length of the axes. They tend in one direction only, that of the rising sap.

30

31

32

35

33

34

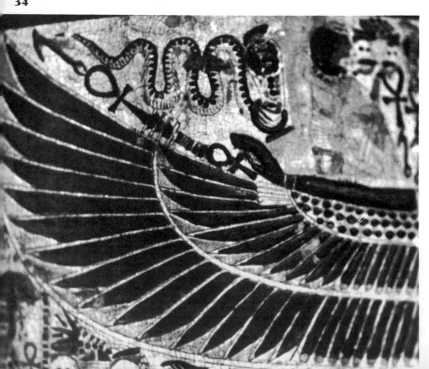

STUDY OF FORMS ADJOINING A NUCLEUS OR A CURVED AXIS

In nature, the mode of distribution of the different parts making up a whole is invariable; each part is allowed to reach the size and to occupy the space it requires in order to fulfil its functions, without in any way impeding the full development of neighbouring elements. Thus, for instance, elements adjoining the interior of a curve draw closer to each other as the available space is reduced; those affixed to the exterior of a curve, on the other hand, become more and more distant from each other as their available space increases.

AESTHETICS

Forms which develop outwards from their starting point give an impression of radiant life approaching the zenith of activity and influence.

Figs. 31, 32, 33, and 34. Note the similar way in which the prickles of a thistle, dandelion seeds, and these stylized scarabaeus and Egyptian duck feathers are affixed.

Fig. 35. Note how the feet are arranged on the curved body of the geophile. Draw a section of this animal to illustrate the harmonious arrangement of the feet in relation to the different depths of the curves.

36

Fig. 36. Crucifixion *(detail) by Grünewald (Colmar Museum.)* *The life and spirit of Christ appear to be leaving the body through the outspread fingers, as if through antennae pointing to all four corners of the sky.*

Fig. 37. *Hands of the dancer Indrani. Even her fingertips express the life and harmony of the dance.*

Figs. 38 and 39. *Life-giving substances are diffused through the radially arranged nerves of the leaf (fig. 39). It is analogous in structure to the piece of jewelry (fig. 38).*

38

39

10. The spiral and the helix

Definitions

A spiral is an open curve described by a point which continually recedes from a fixed centre round which it revolves.

A helix is a left-handed curve obtained by rolling on to a cylinder, cone, or sphere revolving to the right a straight line at an oblique angle to the axis of the solid in question.
A circular helix is obtained by rolling a straight line round a cylinder.
A conical helix is obtained by rolling a straight line round a cone.
A spherical helix is obtained by rolling a straight line round a sphere.

A helicoidal form is a form that manifests all the characteristics of the helix.
Helicoidal motion. In mechanics helicoidal motion is movement of a solid which revolves round a fixed axis while continuing along that same axis. A bolt sinking into its nut, and a corkscrew biting into the cork are examples of helicoidal movement.
 Since in art the object under observation is fixed and immobile, helicoidal movement transfers itself to the spectator instead, as his gaze follows the form of the object. Every eye that contemplates a helicoidal form attentively therefore engenders a helicoidal movement corresponding to that which produced the form in the first place.

A helicoid is a surface formed by the helicoidal movement of a straight line round an axis.

A helicoidal cyme is an inflorescence all of whose branches spring from the same side of an axis along which they are arranged in a helix.
A scorpioid cyme is an inflorescence all of whose branches spring from the same side of an axis along which they are arranged in a spiral.

A spire is a tower topped by a spiral or helix. It is also the name given to a single twist of a spiral shell.
The thread of a helix is the amount by which the helix would move in the course of a complete revolution if its action were contained by a solid fixed bolt.

The spiral and the helix in nature

Of all the movements which characterize natural forms, the most widespread are spiral, or, more precisely, helical movements.

THE PERFECT SPIRAL
A perfect spiral does not exist in nature. Since space has three dimensions, it is in three dimensions that nature tends to develop. Also, in view of the fact that it would be more dynamic, homogeneous, resistant, and thick in some places than others, it is unlikely that a given mass of living matter arranged in the form of a spiral could develop with perfect regularity in a single plane. In fact, every natural spiral form tends to 'warp' (i.e. to depart slightly from the place which should contain it), thereby increasing in depth.
 However, nature often produces almost perfect spirals, thereby leading to the geometric definition of the spiral.

MIXED FORMS
Just as an outline does not consist of a straight line, arc, or parabola alone, but of a mixture of these three fundamental types of line, a natural form is similarly the result of a combination of rectilinear, circular, parabolic, spiral, and helicoidal movements.

HELICOIDAL MOVEMENT
Helicoidal movement is found in man as in all nature. It can be seen in the rotation of the head, the twisting of the body, and the movements of the humerus and the arms. Helicoidal movement allows great variety and flexibility in the transition from one position to another.

CIRCULAR HELICES, THEIR FUNCTIONS AND CHARACTERISTICS
By turning about their axes in a given direction, a screw, a bolt, and a corkscrew work their way into a material (wood, nut, or cork); they work their way out if turned in the opposite direction. Thus all helicoidal movement is bi-directional, depending on whether one is looking at it from end A to end B, or vice versa.
 The closer the thread of a helicoidal form, the longer the eye takes to follow it. The eye can quickly take in the visible part of the thread in fig. 24, p. 70; it takes much longer to count every turn that cotton makes round the cylindrical axis of its reel. Similarly, the more pro-

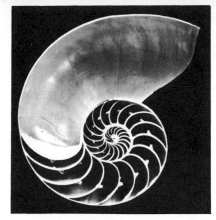
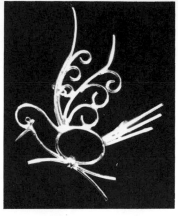

1 2

3

nounced the pitch of its helix, the deeper a metal drill bites with each revolution. As they draw closer together, the spirals of a helicoidal form contract that form; as they draw further apart, they extend it. Aided by the elasticity of certain materials, this flexible transition from one size to another aided in such inventions as the coil spring and the egg whisk.

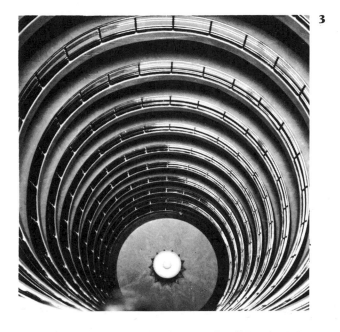

4 5

6 7

Fig. 1. Cross-section of a nautilus shell.

Fig. 2. Piece of jewelry.

Fig. 3. Interior of the tower of the Grand Hotel Duke of Aosta, Sestriere, Italy. The staircase is replaced by a spiral of rooms.

Figs. 4 and 7. Some of these vine tendrils (fig. 4) approach a perfect spiral. The human use of perfect spirals is illustrated by this detail (fig. 7) of a small 19th century table (Musée des Arts Decoratifs, Paris).

Figs. 5 and 6. It takes little to turn a spiral into a helix. The main stem divides to produce a right-hand tendril and a left-hand tendril (fig. 5). This peculiarity recurs in the lower part of this 19th century candlestick (Musée des Arts Decoratifs, Paris). Note the conical helix in the upper section (fig. 6).

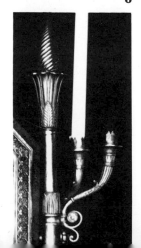

8

9

Fig. 8. A scorpioid cyme that has not yet reached full flower.

Fig. 9. The diagram shows the spiral development of a scorpioid cyme.

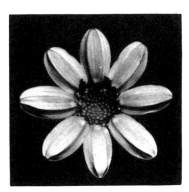

11

10

Fig. 10. Bronze pin (Besançon Museum). A form terminating in a spiral is more concentrated and takes up less volume. Also, when pressed firmly against each other, such forms offer greater resistance to the elements (rain, gusts of wind, etc.). Finally, a spiral of living matter can wind and unwind according to need. This elasticity and resilience provides greater resistance to breakage than an entirely rectilinear form. This quality led to the invention of the spiral spring, a flat spring which is turned about an axis and which regulates the movement of a watch or clock. A spiral spring, unlike a coil spring, manifests its elasticity only in the plane that contains it.

Fig. 11. Single dahlia in full bloom. Note that the petals, which radiate from the heart of the flower to form a circle round it, are not precisely juxtaposed, but overlap slightly at their edges. This overlapping allows a petal to slide over its neighbour when the flower opens and closes. In short, it primes the required helicoidal movement.

Figs. 12 and 13. Rosebud. Helicoidal movement enables the petals of this rosebud to cover each other partially.

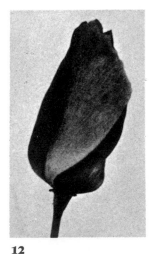
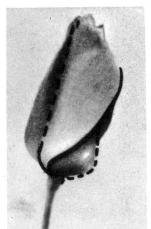

12

13

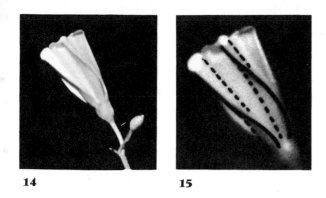

14 **15**

Figs. 14 and 15. Bindweed. As it closes, the flower folds in on itself in a furling movement, similar to what happens when you shut an umbrella by pressing the fabric against the stick while giving the latter a slight twist.

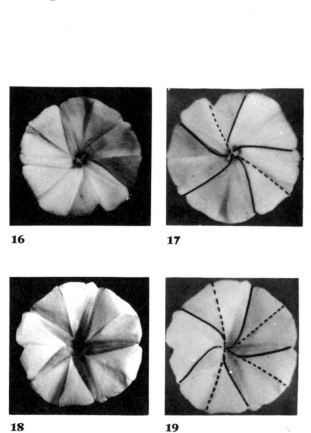

16 **17**

18 **19**

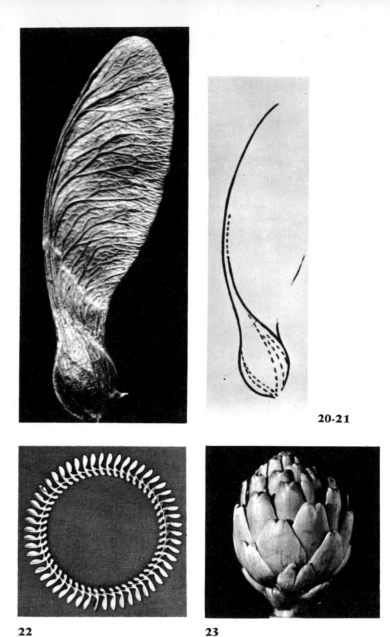

20-21

22 **23**

Figs. 16, 17, 18, and 19. Bindweed in full flower, seen from above and below. Note the straight folding lines of the flower which correspond to the dotted lines in the tracings. Note also that these folding lines alternate with other lines (indicated by the unbroken lines in the tracings) which assume a very definite twist near the heart of the flower.

Figs. 20 and 21. Sycamore seed. The tracing shows the helical movement in the seed and its slightly off-centre flight. As the seed falls from the tree, it revolves round its heaviest extremity, a true helicoidal movement in the direction of the ground. Note the analogy between the form of this seed and that of an aeroplane propeller blade.

Fig. 22. Danish necklace. The motif of this necklace is a stylized sycamore seed with its flight.

Fig. 23. Arranged in either direction in the form of a helix, these artichoke leaves can develop towards the left, towards the right, or upwards, simply by sliding gently over each other.

69

24

25

26

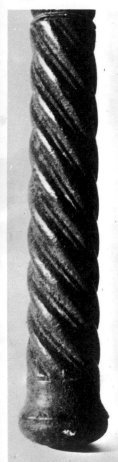

Aesthetics

THE SPIRAL

The closer together the turns of a spiral, the more they focus the gaze and, consequently, the attention. (See fig. 32.) The further apart they are, the more the eye tends to pass over them quickly so that the attention lapses. (See fig. 33.)

To sum up, a spiral attracts and concentrates the gaze on its pole; a spiral invites the gaze to revolve more and more rapidly round its pole and to get further and further away from it.

The progressive speeding up and slowing down of the gaze as it follows a spiral in either direction depends on, and therefore harmonizes with, the number of turns, the space these occupy, and their distance from the observer's eye. Progressive acceleration or deceleration in the movement of the eye can give rise to a certain functional pleasure in the retina and, consequently, to a certain aesthetic pleasure.

The aesthetic pleasure derives from the ease with which a spiral can be scanned and the variation it shows. Its quality depends on the relative concentration of the turns.

As an exercise, take another look at the different spirals depicted in this chapter and try to give a precise definition of the aesthetic quality of each.

THE HELIX AND HELICOIDAL MOVEMENT

Helicoidal movement is appropriate to a three-dimensional form occupying a given space. Helicoidal movement therefore manifests itself only on the visible surface of the form.

While a spiral movement is unbroken because it develops in a single plane which we can see in its entirety, helicoidal movement is often interrupted at the very edge of a form which is not visible to us. In aesthetic terms, all helicoidal movement leads the observer's gaze in the direction in which it develops and invites his mind to guess at the hidden sections.

All partially visible helicoidal movement briefly holds the eye on each of its twists. In many cases one's gaze is forced to jump from one twist to another. (See figs. 38 and 39.)

A helicoidal movement animates a space or a form by giving it an appearance of mobility, i.e. movement of varying rapidity and flexibility. How successfully helicoidal movements in a work of art focus attention on the qualities of any given thought or form varies with the number and extent of their convolutions.

Figs. 24 and 25. Detail of a gear in the form of circular helices. The black lines of the tracing emphasize the 'pitch' of the helix. The pitch of a helix is measured on the perpendicular joining two lines in a section in which they are parallel.

Fig. 26. Lower section of the handle of a flail (Besançon Museum). This metal cylinder is covered with deep helical grooves, the raised portions of which are rounded. If it were entirely smooth, it might have slipped out of the knight's hand in the course of battle. As it is, its helicoidal form keeps it firmly fixed in the hand that grasps it.

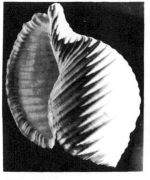

27

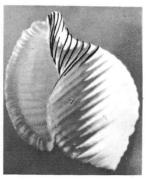

28

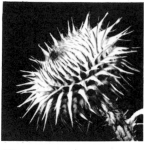

29

30

Figs. 27 and 28. Shell. The spires of this shell appear to have developed in one direction only ; they do not overlap or cross. Overlapping can be seen more clearly in the snail shell in figs. 32 and 33, or by holding a mussel shell against the light. Fibres cross each other in much the same way when radial dispositions are interrupted by concentric dispositions (the composition of wood in general, and of the trunk and branches of a tree in particular). Observe carefully the texture of a heel bone (calcaneum) or the arrangement of the fibres in the different layers that are glued together to form plywood. The black lines on the tracing emphasize the harmonious progression of the upward motion of the spires, while the form about which they revolve becomes smaller and smaller.

Figs. 29 and 30. Thistle flower. This side view clearly shows the helicoidal movement of the plant, which the tracing emphasizes.

Fig. 31. Thistle flower (from above). It appears at first sight to have a concentric radial configuration.

Figs. 32 and 33. These two figures show the two faces of the same shell enlarged four times. Note that the eye follows one spiral more rapidly than the other.

Figs. 34 and 35. Both of these plants illustrate helicoidal movement in two directions (from right to left, and from left to right).

34

35

31

32

33

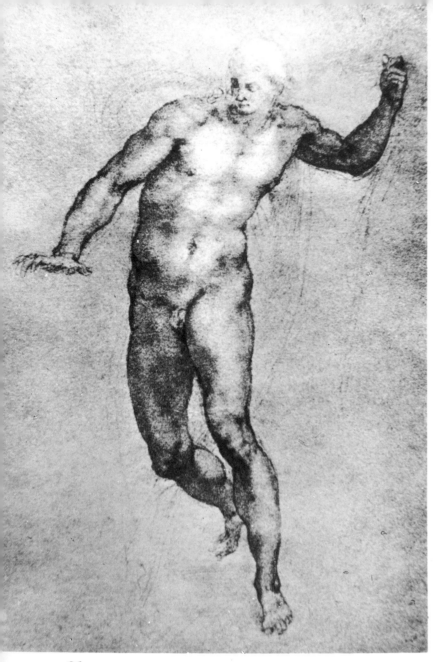

36

Figs. 36 and 37. The Ascension *by Michelangelo. This drawing utilizes a very definite helicoidal movement to symbolize and suggest the 'ascending' movement of Christ. Note how easily your gaze is able to pass from the horizontal position of one hand (a reference to death) to the vertical position of the other, which points towards the sky. Note also the way in which perspective is used to combine the two legs in a tapered form like a column of smoke at its inception.*

Figs. 38 and 39. In the tracing, the ascending movement of the eye, as it scans the visible portion of each convolution, becomes more rapid the further it gets from the central section. This is because it gets progressively closer to the vertical. The opposite aesthetic effect would be obtained if the figure were laid horizontally.

37

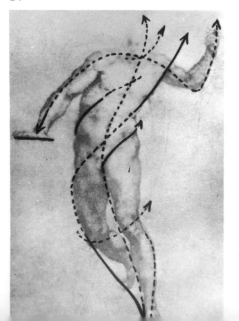

38

39

11. Two-dimensional decorative composition

BASIC TWO-DIMENSIONAL GEOMETRIC FIGURES

In the following chapters you will examine some basic two-dimensional geometric figures and try to discover the principal harmonics which will help you to use these figures in decorative composition. The figures are as follows:

(1) The circle and its variants, the ellipse and the oval.
(2) The equilateral triangle, the isosceles triangle, the right-angled triangle, and the regular hexagon.
(3) The square.
(4) The rectangle.
(5) The regular pentagon.

ELEMENTARY PRINCIPLES OF TWO-DIMENSIONAL DECORATIVE COMPOSITION APPLIED TO A GIVEN FORM

The elementary principles of two-dimensional decorative composition applied to a given form or format enable you to embellish, adorn, and decorate this form while respecting and enhancing the plastic and aesthetic qualities which are proper to it.

'Composition, whose goal should be expression, varies according to the surface to be covered. If I take a sheet of paper of a given dimension and make a drawing on it, that drawing will have a necessary, specific relationship with that format. I would not repeat the same drawing on another sheet of different dimensions.' (Matisse.)

These aesthetic qualities of a given form, of a specific given format, are underlined and reinforced by their harmonics or lines of partition. A preliminary schematic sketch of the harmonics of a form will help you to find the disposition, the direction, and the extent best suited to the decoration in hand.

Note: Though receiving the judicious support of certain harmonic structures, every project, rough, or sketch for a decoration should be revised, worked, and corrected in accordance with the general criteria previously laid down, particularly in Chapters 2, 5, 7, 8, and 9.

Fig. 1. Repetition of circles within circles.

Fig. 2. Lines within a circle by Giora Novak.

Fig. 3. Rectilinear axes.

Fig. 4. Curvilinear axes.

Fig. 5. Arcs shared by interlocking circles.

You should never start a composition without having determined its format in advance. Though a sheet of paper easily lends itself to subsequent modifications of proportion, the same does not hold true of a plate, a wall, or a tray.

The circle, its harmonics, and its decoration

THE CIRCLE

The circle is the simplest two-dimensional geometric form, the purest and, consequently, the easiest to imagine. In fact a circle is delimited only by a single closed line called a circumference, every point of which is equidistant from a point known as the centre. In addition, each part of a given circumference has the same curvature.

AESTHETICS OF THE CIRCLE

The primary aesthetic quality of a circle is the perfect fullness of its outline. It is the same with a sphere, whose outline, from whatever angle you look at it, is always a perfect circumference.

The perfection of a circle is related to the fact that its radii are of equal length. This feeling of perfection in the fullness of the circle can be reinforced aesthetically by the familiar expedient of repetition, that is to say, by the arrangement within a circle of other circles with narrower diameters. (See figs. 2 and 8, pp. 60 and 61 respectively.)

HARMONICS OF THE CIRCLE

The purpose of the primary harmonic lines of the circle is to heighten the perfection, simplicity, and fullness of the latter's circumference and, consequently, to concentrate attention on the interior of the form. These harmonics are therefore produced by concentric circles. They depend on the principle of concentricity.

In following the outline of a circle, the eye carries out a straightforward, even, rotating movement in one direction or the other.

The circle lends itself perfectly to rotating movement. Circular and spherical forms are ideal for everything that rolls or turns about an axis or centre (bicycle wheels, car wheels, wheels in machinery, etc.). The second aesthetic quality of a circle is to provide a sense of the perfection and natural ease of rotating movement.

2

3

4

5

6

The sense of perfection inherent in the form of the circle leads you to sense the existence of a centre from which lines of equal importance, force, and size issue towards the perimeter. These lines are described in geometric terms as the paths of the radii.

The eye can follow the radii of a circle in two different ways:

(1) By going from the centre towards the circumference (centrifugal movement).

(2) By going from the circumference towards the centre (centripetal movement).

Furthermore, the feeling of perfect rotating movement about a centre implies a perfect balance of the radii and the surfaces they delimit. The third aesthetic quality of a circle, then, is to produce a sense of perfectly balanced radiation corresponding to a perfectly uniform rotating movement.

OTHER HARMONICS OF THE CIRCLE

The secondary harmonics of the circle have as their aim the division of the surface into sectors which, while arranged so as to balance each other perfectly and harmoniously, also respect and heighten the centripetal or centrifugal dynamism of radial forms.

In geometry these harmonics coincide with the lines of the radii. They are governed by the principle of radiation. (See the examples of natural radiation on p. 61.)

Of course, the ultimate use of these forms in a work of art will not necessarily be in strict accordance with the principles outlined here. The fact that Giora Novak's circle design (fig. 2, p. 73) is not based on the application of either the principle of radiation or that of concentricity matters little, since he appears to have been entirely successful in producing a pattern which is in harmony with the perfect form of the circle.

7

The following are examples of composition within a circular form:

Fig. 6. Well wheel (courtyard of the Hôtel-Dieu, Beaune). The design of this wheel, reminiscent of a rose window in a cathedral, represents a happy combination of concentricity and radiation.

Fig. 7. Flower under strong light. Its radial form and tiny florets standing out in white on a black ground are reminiscent of an exploding firework.

Fig. 8. Door knob (Dijon Museum). A combination of radial and concentric modes.

Fig. 9. Diatoms.

Fig. 10. Thistle. A form with a radial appearance.

8

10

9

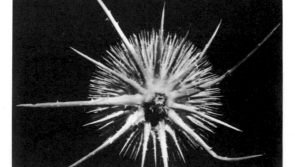

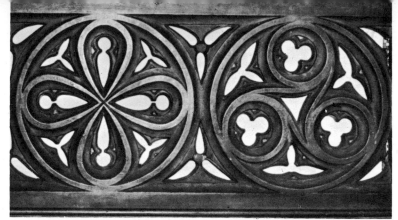

11

12

13

14

Fig. 11. Decoration (Besançon Cathedral). Note the balance and movement in this circle containing three other circles. The impression is a combination of radiation, concentricity, and movement.

Fig. 12. This glass jam dish exhibits a concentric effect. The beading holds your attention and forces your gaze to describe a rotating movement.

Fig. 13. Decoration (Besançon Museum). Here the importance of concentricity far outweighs that of radiation.

Fig. 14. Bracelets (Danish boutique, Paris). The form and arrangement of the component elements produce respectively a rectilinear and a giratory effect.

Fig. 15. Gouache by Lilly Greenham. As a result of skilful arrangement and variations in angles of inclination, in values, and in surfaces, certain elements of this composition appear to turn in a circle.

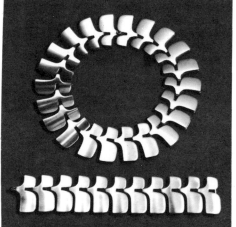

15

12. Triangles

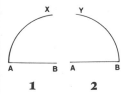

1 2

The equilateral triangle

3

4

5

6

An equilateral triangle is a two-dimensional closed geometric figure with three equal angles and three equal sides.

DRAWING AN EQUILATERAL TRIANGLE

To form an equilateral triangle, take the length AB of one side as the radius of a circle. Describe an arc AX, having as its centre the point B. Then describe an arc BY, having as its centre the point A. Make sure that the arcs are drawn on the same side of the line AB, and in such a way that they intersect at a point C, which represents the apex of the equilateral triangle ABC. (See figs. 1, 2, and 3.)

Note: Since only the position of point C matters, the arcs AX and BY need only be described in the immediate vicinity of their probable point of intersection. (See fig. 4.) In this way you avoid having to erase marks whose additional extent serves no useful purpose.

THE EQUILATERAL TRIANGLE AND THE CIRCLE

An equilateral triangle can be inscribed in a circle. (See fig. 5.)

A circle can be inscribed in an equilateral triangle. (See fig. 6.)

However, by virtue of its three straight sides, the equilateral triangle does not share the circle's property of retaining the same appearance while revolving round its centre.

In fact, an equilateral triangle may be inclined either to the left or the right (figs. 9 and 10); perpendicular on its horizontal base (fig. 7); or in perfect balance on the point of an angle whose bisector is vertical (fig. 8).

THE HARMONICS OF THE EQUILATERAL TRIANGLE

The harmonics which best serve and enhance the characteristics of an equilateral triangle are lines drawn parallel to the sides to form concentric equilateral triangles (fig. 11).

In an equilateral triangle each line bisecting each angle is at one and the same time height, median, and perpendicular bisector. All lines dividing it into equal or symmetrical parts are harmonics of the equilateral triangle.

7 8

9 10

11

12

Fig. 12. An equilateral triangle is divided into two equal and symmetrical parts by a median. Each of these two parts is a right-angled triangle. A right-angled triangle can therefore integrate itself into an equilateral triangle and harmonize with it.

Fig. 13. The harmonics of the right-angled triangles are lines drawn parallel to the sides to form right-angled triangles inscribed within each other.

Fig. 14. A single median dividing an equilateral triangle into two equal parts gives to a decoration a direction corresponding to that in which the two right-angled triangles are pointing.

Fig. 15. The harmonics of the equilateral triangle include the three heights, medians, perpendicular bisectors, and the three lines bisecting the angles. All of them intersect at the same point at the centre of the figure.

The three medians divide an equilateral triangle into six equal parts, symmetrical two by two in relation to each of these medians. Each of these six parts is a right-angled triangle.

Fig. 16. If you extend the medians as far as the circumference of the circle in which the equilateral triangle is inscribed, three points are obtained, which, joined to the vertices of the triangle, determine a regular hexagon. This regular hexagon is found to contain twelve equal right-angled triangles or three regular lozenges, each comprising four equal and symmetrical right-angled triangles.

A lozenge can therefore integrate itself into a regular hexagon and harmonize with it (see fig. 51, p. 79).

Figs. 17 and 18. By joining two by two the three points previously obtained by extending the medians of an equilateral triangle as far as the circumference of the circle in which they are inscribed, a second equilateral triangle is obtained, inverted in relation to the first and forming with the latter a star with six points.

This six point star contains six equal equilateral triangles, the bases of which form a regular hexagon in the central part of the figure.

Fig. 19. By joining two by two the median points of the sides of an equilateral triangle, you obtain four equilateral triangles, equal and symmetrical two by two. You can also see three regular and equal lozenges, all having half a lozenge in common.

Fig. 20. By drawing the medians from the mid-point of each of the sides as far as their common point of intersection, you form within an equilateral triangle three equal parts which are symmetrical two by two.

Fig. 21. By drawing the medians of an equilateral triangle from their vertices to their common point of intersection, you get three equal isosceles triangles which are symmetrical two by two.

13

14

15

16

17

18

19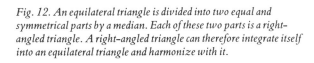

 20 **21** **22** **23** **24** **25** **26**

The isosceles triangle

An isoscles triangle is a two-dimensional closed geometric figure with two equal sides and two equal angles. The third side is the base.

HARMONICS OF ISOSCELES TRIANGLES
The harmonics of isosceles triangles are:

(1) Lines drawn parallel to the sides to form isosceles triangles inscribed within each other (fig. 27).

(2) The three lines bisecting the angles (fig. 28).

Note: The other harmonics of the isosceles triangle alter the aesthetic character of the triangle to which they are applied in varying degrees. (See figs. 35, 36, 37, 38, 39, and 40.)

ISOSCELES TRIANGLES AND THEIR AESTHETICS
Exercise: Study all these figures and try to find equal, symmetrical, or similar triangles in them.

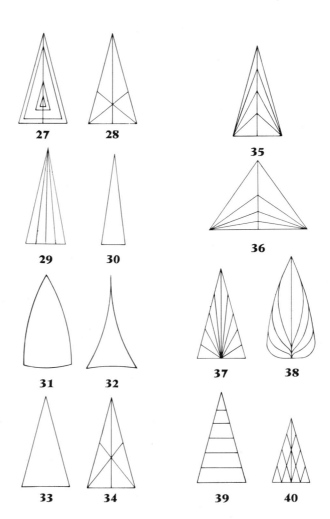

Fig. 22. Other harmonics.

Fig. 23. Equilateral convex curvilinear triangle.

Fig. 24. Equilateral concave curvilinear triangle.

Fig. 25. Equilateral triangle with rounded vertices.

Fig. 26. Convex curvilinear triangle with rounded vertices. Plan of a cross section taken half-way up a tulip seed. Note the disposition of the internal elements in accordance with the principle of the harmonics of the equilateral triangle.

Fig. 29. Standing perpendicular on its base, an isosceles triangle which is taller than it is wide, and which is divided vertically into sections by lines issuing from its apex, gives an impression of increased size, height, and dominance.

An isosceles triangle whose base is larger than its height gives an impression ranging from stability and restful equilibrium to crumbling collapse (fig. 36, and the lower section of fig. 35).

Fig. 30. An isosceles triangle with a very small base in relation to its height, and slightly convex curvilinear sides, gives an impression of a dangerously, even aggressively, sharp pointed object: for example, the very sharply pointed end of a thistle (fig. 41, p. 78).

Fig. 31. An isosceles triangle with convex curvilinear sides gives an impression of fullness and vigour.

Fig. 32. An isosceles triangle with concave sides seems to bow under an external weight. Its overall surface is reduced, and its apex is sharpened; it gains in lightness and elegance what the triangle with convex sides gains in force and fullness.

Figs. 33 and 34. Triangle divided by its medians.

Figs. 35 and 36. Impression of progressive elevation or flattening.

Fig. 37. Impression of contained radiation working towards the apex.

Fig. 38. Curvilinear sides imply internal harmonics which are themselves curvilinear.

Fig. 39. In an isosceles triangle, lines parallel to the base hold one's gaze and attention.

Fig. 40. Lines parallel to the two longer sides intersect to form lozenges (in this case regular and equal lozenges).

41

42

45

46

47

48

43

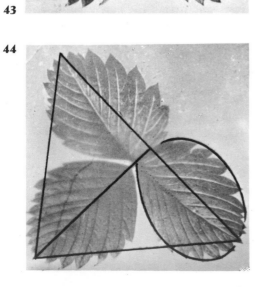

44

49

50 **51**

Fig. 41. Thistle leaf.

Fig. 42. Spire of the Hôtel-Dieu, Beaune.

Figs. 43 and 44. Strawberry leaf. This symmetrical trefoil fits perfectly into an equilateral triangle formed by joining the furthest points of the three principal nerves. Note that the two halves of the left-hand leaf are identical but reversed.

Fig. 45. Sycamore seed.

Fig. 46. Sycamore seed without its flights.

Fig. 47. Diagram showing the equilateral triangle which can be drawn round the seed, and the harmonics of that triangle.

Figs. 48 and 49. Iris flower. The flower is composed of six petals disposed along the medians of two equilateral triangles. This arrangement in the form of an equilateral triangle can be seen more clearly after three of its six petals have been removed.

Figs. 50 and 51. Mosaic motif (Besançon Museum). The tracing shows equilateral triangles, hexagons, and lozenges.

Fig. 52. Vase with neck in the form of a duck (Musée des Arts Decoratifs, Paris). Where the body of the vase narrows to become the neck, the hexagonal decoration unobtrusively gives way to lozenges.

Fig. 53. Fish (detail of an Egyptian painting). The scales have been stylized, and are depicted in the form of boldly drawn lozenges.

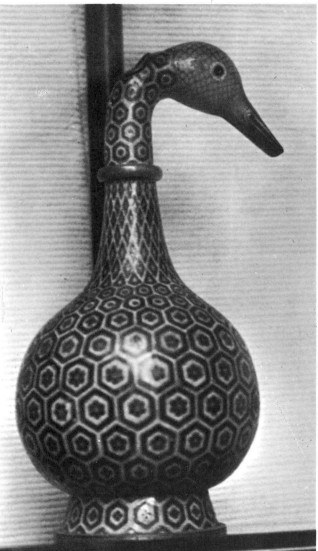

52

53

13. The square

A square is a two-dimensional, closed geometric figure whose four sides are equal and whose four angles are right angles.

THE HARMONICS OF THE SQUARE

The harmonics of the square are lines which divide it while reinforcing its aesthetic character.

A square can be divided:

(1) By one of its diagonals (fig. 1). The square is divided into two equal and symmetrical right-angled triangles.

(2) By the other of its diagonals (fig. 2). Note that the eye is drawn in the direction in which the diagonals are inclined.

(3) By both of its diagonals (fig. 3).

The two diagonals of a square are two axes of symmetry dividing the square into four equal right-angled isosceles triangles that are diametrically opposed at their apex. As in the two preceding figures, each of these right-angled isosceles triangles is equivalent to half a square.

(4) By one of its two medians (fig. 4).

(5) By the other of its two medians (fig. 5). A median is an axis of symmetry dividing a square into two equal rectangles, each of which is twice as long as it is wide.

In a square a vertical median gives an impression of height, a horizontal median an impression of length.

(6) By both its medians (fig. 6). The two medians of a square are two axes of symmetry dividing the square into four equal squares.

(7) By its two medians and its two diagonals (fig. 7). The medians and the diagonals of a square divide the square into eight equal, right-angled isosceles triangles that are diametrically opposed and symmetrical two by two in relation to each of the medians and the diagonals.

(8) Into equal, symmetrical sections by a circle drawn through the extremities of the medians and having the mid-point of the square as its centre. A circle having a median as its diameter fits into that square (fig. 8). But a square fits into a circle whose diameter is represented by one of the diagonals of the square (fig. 9).

Squares and circles are geometric figures which can be combined harmoniously in designing decorative motifs.

(9) By other squares inscribed within each other and sharing a common centre (fig. 10).

(10) By parallel lines which are symmetrical either in relation to one diagonal or the other (figs. 11 and 12).

These harmonics give the square a direction, as in figs. 1 and 2.

(11) By a square formed by joining two by two the median points of the sides. The figure thus obtained is in perfect balance (fig. 13), as in fig. 14, which represents two equal squares having the same centre, one of which has gone through a rotation of 45° in relation to the other.

(12) By two half diagonals intersecting at the centre with a half median (fig. 15).

(13) By lines parallel to the sides, intersecting with each other to form a square in the centre and a square at each corner (fig. 16).

(14) By lines symmetrically arranged in relation either to the vertical (fig. 17) or to the horizontal median (fig. 18).

Note: In these figures an optical illusion is created whereby the square appears either higher or wider, respectively, than it actually is.

(15) By lines parallel to the diagonals which intersect to form a square in their centre (fig. 19).

Study the twenty-three diagrams on this page. Do all these schemes have the same aesthetic value in relation to the characteristics of the square form? Work out other schemes suitable for use in square-based designs.

24

25

26

28

29

Fig. 24. This flower fits into a square formed by joining the furthest points of its four petals. The axes of the petals coincide with the diagonals of the imaginary square.

Figs. 25 and 26. The embranchments of the natural form are arranged according to the pattern in fig. 20. The same pattern occurs in the ceiling of a chapel in the Cathedral of Saint-Jean in Besançon.

Fig. 27. The notion of the square is suggested to us by nature, as here in the skin of a plucked duck.

Fig. 28. Alms chest in the Hôtel-Dieu, Beaune (detail). An iron decorative figure is contained in a square at whose centre there is a form which could be inscribed in another much smaller square, and which shows a certain analogy with the pattern in fig. 21.

Fig. 29. Pulpit in the Cathedral of Saint-Jean, Besançon (detail). In this architectural detail you can make out a circle inscribed in a square, a square with concave curvilinear sides inscribed in this circle, as well as small convex curvilinear squares, in which the spaces are arranged like the petals in fig. 26. Note the presence and the form of the triangles and the lozenges.

Fig. 30. Composition by Anuszkiewicz. This arrangement of concentric squares gives the impression of radiations emanating from the centre of the design.

27

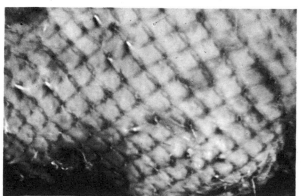

30

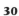

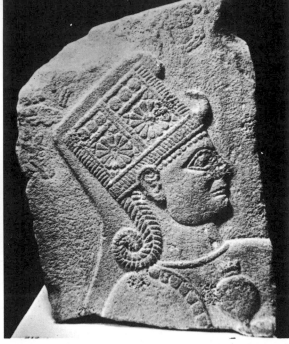

31

32

33

34

35

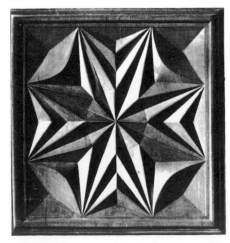

36

Fig. 31. Ancient bas-relief (Louvre). In the head-dress two motifs consisting of daisies set in two juxtaposed squares can be distinguished.

Fig. 32. A circle could be described round this flower, passing through the tip of each of its eight petals. By joining the tip of one petal to that of its neighbour, a regular octagon would be obtained. The petals could also be joined to get two squares having the same centre but rotated through an angle of 45° in relation to each other. (See fig. 14, p. 80.) The heart of this daisy is in the form of an octagon with concave sides.

Fig. 33. Grill (Florence, 15th century). Make diagrams of these decorations, and interpret them so that you can create other motifs of an analogous aesthetic character.

Figs. 34 and 35. Fragments of mosaics (Lyons). Study the composition inside each large square and draw diagrams of it to indicate the harmonics. Using these diagrams, design original motifs.

Fig. 36. Detail of antique furniture. Trace the medians and diagonals of this motif. Determine the exact position of the extremes of the eight point star. Using this pattern as a starting point, design other analogous motifs with slightly different internal proportions.

37

38

39

Figs. 37 and 38. 18th century ceramic ware (Musée des Arts Décoratifs, Paris). The pattern in fig. 14 on p. 80 is recognizable in this tile. Within the first motif is inscribed a circle containing a second motif, whose sides are parallel to those of the first.

Fig. 39. Yugoslav embroidery design. This is the same basic pattern as in figs. 37 and 38, except that the internal arrangement of the decorative elements is different.

Fig. 40. Yugoslav embroidery. Every alternate square is embroidered with the same pattern as in fig. 43. Note that the half diagonal is indicated simply by a difference in the tone of the materials employed.

Figs. 41 and 42. Yugoslav embroideries. Find the harmonics of these different embroidery motifs. Make simplified diagrams of them, and use the diagrams to work out new decorative devices.

Fig. 43. Detail of a stained glass window in the Hôtel-Dieu, Beaune. In this window the harmonics of the square consist of two half medians joining up with the opposing half diagonal.

Fig. 44. Despite the extreme sobriety of the techniques employed in this composition by Ernst Benkert, movement and richness triumph over monotony.

40

41

42

43

44

14. The rectangle

1

2

3

4

5

THE HARMONICS OF THE RECTANGLE

The principal harmonics of the rectangle are:

 (1) The diagonals
 (2) The medians
 (3) Lines parallel to the sides
 (4) Concentric rectangles inscribed within each other.

In view of the fact that the rectangle and the square share certain characteristics, the reader is advised to refer to the illustrated list of the harmonics of the square on p. 80, and then to work out for himself the different harmonic patterns of the rectangle.

THE GOLDEN MEAN AND THE GOLDEN RECTANGLE

There is a certain proportion between the width and the length of a rectancle which is particularly harmonious. Already familiar to artists and architects in antiquity, it was called 'the golden mean' in the Renaissance, and in the 20th century it inspired the architect Le Corbusier to create his famous 'modulor'. This proportion is roughly $1:1\cdot618$ or more precisely $\dfrac{1+\sqrt{5}}{2}$.

THE GOLDEN MEAN AND AESTHETICS

As stated previously, the very essence of harmony lies in the accomplishment of an end by the most economical means.

There is no beauty without economy and, therefore, without simplicity. It is doubtless for this reason that we are aesthetically satisfied by a circle, a square, or an equilateral triangle, which are simple forms, easy to perceive, and consequently familiar. But how does this celebrated 'golden mean' tie in with simplicity?

First draw a 'golden rectangle' ABCD 1 unit wide and 1·618 units long, and then, inside this rectangle, a square ECDF with sides 1 unit in length. The complementary figure ABEF forms a second golden rectangle, i.e. a rectangle whose proportions are in the ratio $1:1\cdot618$.

Thus, implicit in any golden rectangle are a square (the most simple form of rectangle) and a second golden rectangle whose beauty serves to enhance that of the initial rectangle by repetition, itself the simplest mode of composition. Then take BC as a side, and draw another square BCGH; the resultant large rectangle ADHG turns out to be yet another 'golden rectangle'.

The 'golden mean' crops up again in the ratio between the length of the radius of the circle drawn round a regular decagon, and the length of one of its sides. (Check against fig. 5.)

15. The pentagon

1

2

Opposite :

Figs. 1 and 2. In this furniture panel (Dijon Museum), the corners of the concentric rectangles are located along the lines bisecting the angles of the main rectangle, and not along its diagonals. How would the panel be affected if the form were square? The centre of the concentric rectangles, whose corners are set along the lines bisecting the angles of the main surrounding rectangle, occurs at the point of intersection of the diagonals. Does the same hold true for a square?

Figs. 3 and 4. Antique furniture panel. The carved elements of this panel are symmetrical two by two in relation to the medians alone. In a square they would be symmetrical two by two in relation to both the medians and the diagonals. Make sketches and tracings to demonstrate this.

A pentagon is a two-dimensional, closed geometric figure having five angles and five sides. A regular pentagon is a polygon with five equal sides and five equal angles. Nature provides numerous examples of pentagonal forms.

Note: The word 'pentagonal' is commonly used to describe every form that can be contained within a pentagon and which has five vertices, five radii, and a centre.

Different pentagons

THE REGULAR CONVEX PENTAGON

To draw a regular convex pentagon, take a circle centre O with its two diameters AB and CD meeting at right angles. (Fig. 1.)

Let I be the mid-point of the radius OC. (Fig. 2.)

A circle with centre I passing through A cuts the extended diameter CD at N and N^1 respectively. (Fig. 5.)

Describe two large arcs centre A, the one having as its radius AN and the other AN^1. Their points of intersection with the circle centre O will divide this circle into five equal parts. By joining these points in succession a regular convex pentagon is obtained. (Fig. 6.)

THE STAR PENTAGON

By joining the five points previously obtained on the circle centre O not one by one but two by two, you can construct a regular star pentagon. The star pentagon in fig. 3 is obtained by joining A to C, C to E, E to B, B to D, D to A.

In the middle of the regular star pentagon a regular convex pentagon is formed. This observation points to a method of forming a star pentagon from a convex pentagon. To do this, extend all sides of a regular pentagon until they intersect.

TRANSITION FROM THE STAR PENTAGON TO THE STAR DECAGON

The fact that in natural objects multiple pentagonal dispositions often occur makes it very easy to proceed from the pentagon to the decagon.

3

4

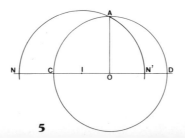

5

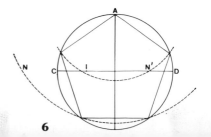

6

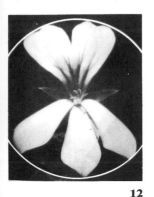

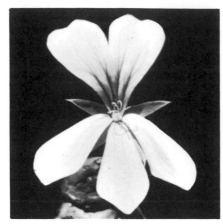

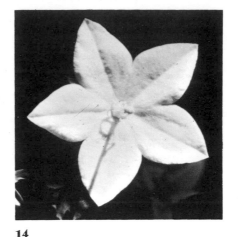

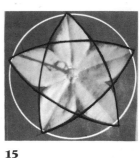

12 **13** **14** **15**

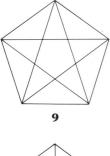

7

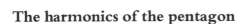

8

9

10

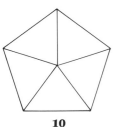

11

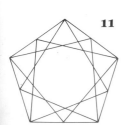

To form a star decagon from a star pentagon (fig. 11):

(1) Find the mid-points of the arcs that link the tip of one branch of the pentagon to the next. Lines issuing from the tips of the branches of a regular pentagon and passing through the centre O of this pentagon cut the opposing arcs at their mid-points. (Fig. 3, p. 85.)

(2) By joining these new points in the same manner as before, a second star pentagon similar to the first is obtained which, when added to it, forms a star decagon.

Another way to construct a star decagon is to divide a circle into ten equal parts. Join in groups of three the ten points arranged round the circumference. (Fig. 4, p. 85.)

Note the difference in aesthetic effect resulting from the different methods of construction of these two star decagons.

The harmonics of the pentagon

The principal harmonics of the regular pentagon are:

(1) The lines parallel to the sides (fig. 7).

(2) The apothegms, i.e. perpendiculars dropped from the centre of a regular pentagon on to each of its sides (fig. 8).

(3) The lines joining the summits two by two (fig. 9).

(4) The radii, i.e. the lines joining the centre to the summits (fig. 10).

Fig. 11 shows the harmonics obtained by joining one summit to the mid-point of the subsequent side, and so on for each remaining summit. In the middle of this regular pentagon a regular decagon is formed.

Exercise: Try to discover other harmonics and other patterns for pentagonal figures, either on the basis of the four principal harmonics shown, or by observing natural forms. From these new patterns think up new motifs.

The photographs shown here depict natural objects as opposed to man-made artifacts. The aim is to encourage the imagination to further development on the basis of what has already been learned in the previous chapters.

Fig. 12. The tracing of this figure shows that the five petals of the flower are so arranged that a circle could encompass them.

Fig. 13. The five petals of this flower are not regularly arranged.

Figs. 14 and 15. The five symmetrical petals of this flower form a regular star pentagon. The sides of the pentagon are slightly convex, as is the case in all living forms. Generally speaking, a regular pentagon, like any other polygon, can be inscribed in a circle.

86

16

17

18 **19**

20 **21**

22 **23**

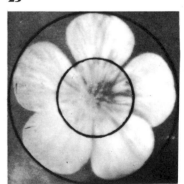

24 **25**

Fig. 16. This leaf, which can be contained within a pentagon, provides an example of almost perfect symmetry.

Fig. 17. The tracing emphasizes the convex character of this leaf's five principal components.

Figs. 18 and 19. Another example of the star pentagon.

Figs. 20 and 21. The same natural objects as above, seen from below. The diagram on the tracing paper emphasizes the centre, the radii, and the apothegms.

Figs. 22 and 23. Although it has five regularly distributed petals, this buttercup corresponds more to a circular than to a pentagonal form. A circle can be considered geometrically as a regular convex polygon with an infinite number of sides.

Figs. 24 and 25. The calyx of this rosebud is composed of five sections arranged in the form of a pentagon. The tracing emphasizes the very simple linear rhythm of the rosebud.

26

27
28

Figs. 26 and 27. Another example of a rose calyx. The tracing shows the relation to the harmonic scheme shown in fig. 10, p. 86.

Figs. 28 and 29. Flower in the form of a star pentagon. The tracing demonstrates the simplicity and beauty of the construction and form of the petals.

Fig. 30. Fossil in the form of a star pentagon. The graphic quality of the outline is quite remarkable.

Fig. 31. The overall shape of this plant (in the form of a star pentagon) presents only convex faces.

Figs. 32 and 33. Leaf inscribable in an irregular pentagon. The tracing shows the path of the three principal nerves (right side and centre). This leaf has an irregular pentagonal shape because its radii are of unequal length.

29

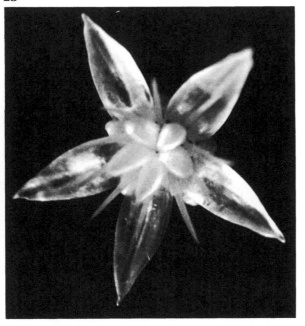

32

33

30

31

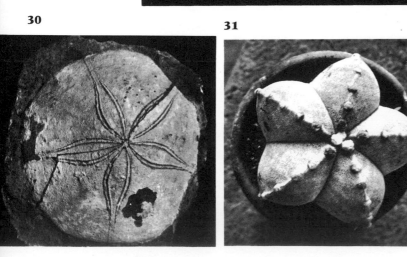

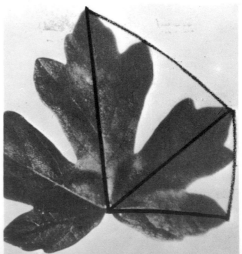

16. Decorative composition

1

This chapter will examine the basic modes of two-dimensional goemetric decorative composition, the different dispositions, arrangements, and possible combinations of motifs.

A fundamental mode of composition: Repetition

When you open your eyes to nature, you soon become familiar with the notion of repetition. But repetition also abounds in the works of man.

REPETITION AND ITS PRACTICAL VIRTUES
Repetition is the simplest and the most practical mode of composition.

It is the simplest because it demands only the creation of a single motif and because it allows only one possible combination.

It is the most practical because with the aid of tracing paper, a stencil, a wood block, etc., this unique motif can very easily be reproduced several times on the surface to be decorated.

REPETITION AND ITS AESTHETIC QUALITIES
Repeated identical motifs fix the attention, they assault the eye and the mind with successive images of one and the same thing, thereby acting upon the observer's memory and sensibilities.

Repetition accentuates the beauty of a motif by multiplying it. In this way it imposes the aesthetic character of the motif.

Well-orchestrated rhythmic repetition gives an impression of measured movement, regular and harmonious, recurring like a refrain.

Repetition, finally, produces an effect of richness and power through the very simplicity of its mode, a simplicity which the number of repeated motifs, however large, never impairs.

ANALYSIS OF THE VARIOUS SPECIFIC MODES OF REPETITION
 (1) *Motifs repeated along a single line*
The single line along which the motif is repeated can be straight or broken, an open or a closed curve (figs. 1 and 2). For example, a necklace composed of identical pearls can be arranged in a straight line, a zig-zag, an open curve, a closed curve, or a perfect circle.

G

2

(4) *Motifs repeated symmetrically two by two in relation to a curved axis*

The aesthetic effects are those inherent in repetition itself as a device, with the further addition of specific effects due to the quality of the curve of the axis. An example from nature is a millipede changing direction.

A second fundamental mode of composition: Alternation

In art, alternation is a succession of different motifs recurring in a regular sequence, thus it is necessarily accompanied by repetition.

An alternation creates a rhythm. Regularity and richness of rhythm combined with variety within an overall unity represent the principle of beauty inherent in all alternation.

ALTERNATION AND THE DESIGN OF A MOTIF
Any plastic element can alternate with another, with two others, or with several others to form a complete motif.

In alternation, therefore, there are as many modes of repetition as there are associations between the different plastic elements entering into the design of a motif or a work.

Within a motif you can consider alternating:

(1) *Positions*. (One element of the motif is repeated in a different position.)

(2) *Proportions*. (The same element is repeated but on a larger or smaller scale.)

(3) *Lines*. (Curves alternate with straight lines, spirals with parabolas, linear rhythms with non-linear ones, and so on.)

(4) *Values*. (Dark colors alternate with light colors, blacks with whites, heavy strokes with light ones, or full areas with empty ones.)

(5) *Colors*.

(6) *Materials*. (One type of wood alternates with another, glass with lead, etc.)

The aesthetic effects which depend on the repetition of identical motifs along a single line are similar to those of the line itself.

(2) *Motifs repeated symmetrically round a point*
This mode of repetition leads to concentric or radiate effects, or to both simultaneously.

(3) *Motifs repeated symmetrically in relation to a rectilinear axis*
Identical motifs arranged symmetrically in relation to, and at a constant distance from, a rectilinear axis are in parallel rows. (See fig. 2.)

A third fundamental mode of composition: Superimposition

One group of horizontally aligned motifs can be superimposed, without touching, on to another group of similar or dissimilar motifs themselves horizontally aligned. In fact all repetition is juxtaposition or superimposition. By 'superimposition', however, we mean a fundamental mode of composition in which motifs or plastic elements overlap, entwine, entangle, or are placed on top of one another.

PRINCIPAL AESTHETIC EFFECTS OF SUPERIMPOSITION

(1) One motif superimposed on another produces a complementary effect, and the resultant combined design has a certain capacity to evoke ideas or feelings.

(2) Motifs partially superimposed and pointing in a given direction can focus the viewer's gaze in this direction while increasing the impression of movement (the principle by which images are linked in cinematography).

(3) Superimposed motifs clearly differing from one another, whether in dimension, value, or significance, can give rise to strange or fantastic impressions, as in the superimposition of different images that occur in dreams.

(4) Motifs superimposed for aesthetic pleasure alone can be the basic plastic elements of works of art, as in the paper collages of Braque and Picasso.

(5) The technique of superimposing and interweaving of different carefully selected and arranged materials is a source of aesthetic joy and decorative richness.

A fourth fundamental mode of composition: Inversion

To invert is to turn or displace an element in relation to its usual position, or to reverse the relative dimensions.

To invert is to stand things on their heads, to paint small what was large and large what was small, black what was white and white what was black.

AESTHETIC EFFECTS OF INVERSION

Inversion permits unexpected, surprising, or amusing effects. Because it has an element of the unusual, the unaccustomed, or the strange, inversion attracts and holds one's attention; it amuses and intrigues.

DEFINITIONS

Traceries are decorative elements or motifs whose lines cross or interlace (fig. 12).

Arabesques are decorative traceries consisting of lines, leaves, letters, geometric or stylized elements fancifully intertwined.

Foliage is a motif of boughs or branches. Foliage can also take the form of arabesques of stylized flowers, leaves, and fruits.

A volute is an architectural motif carved in the form of a spiral or helix.

Flowerwork is decoration in the form of a flower.

A palmette is an ornament in the form of a palm or of a hand with outspread fingers.

A decorated capital is a large decorated letter such as is used at the beginning of a chapter.

A ruche is a frill of tulle or lace used to decorate the neck, sleeves, etc. of a garment.

Guipure is a sort of lace whose decorative motifs are separated by large open areas.

Borders

A border is that which represents the edge of a thing, or that which limits any given surface.

THE BORDER AND NATURE

In nature, a border is that which marks the outline of a thing or a creature by decorating or strengthening it (figs. 13 and 14).

THE BORDER AND ART

In art, a border frames a decoration; it clearly defines its limits by separating it from other elements in the immediate vicinity.

A border adds the richness of its decoration to the subject it contains (fig. 15).

A border holds the gaze within its confines (fig. 16).

A border isolates what it delimits (fig. 17).

AESTHETICS

A border frames, isolates, and delimits a decoration; it concentrates attention on a work and adds embellishment. But on no account should a border ever become the focal point of a work. Its job is to harmonize with the overall design of which it is a part, either by serving as a link between the background and the decoration as a whole, or simply by representing its logical limit or outline.

Friezes

A frieze is a precisely delimited, flat, unbroken surface. In general a frieze is a band of ornamentation or decoration, a complete entity in itself, with a clearly defined place in the work as a whole.

A frieze does not frame a work; but it often assumes a major and specific significance, as is the case with the Panathenian frieze which decorates the Parthenon.

Bands

A band is a surface much longer than it is wide. It can be decorated, ornamented, or plain.

As a mode of composition, repetition gives a certain additional beauty to the aesthetics of repeated bands (textile designs, house façades, all-over patterns, etc.).

3

Fig. 3. Plant study by Leonardo da Vinci. This is an example of the overlapping of different parts of a plant.

4 **5**

Fig. 4. Small details repeat themselves in an almost straight line along the ridges of this plant.

Fig. 5. Cactus. Minor elements are repeated on the surface of a body to form an overall pattern.

Opposite:

Fig. 6. Examples of the repetition of symmetrical motifs arranged in open semi-circular curves, broken lines, and circles.

Fig. 7. Shell. Motifs arranged in repeating bands are themselves repeated. Note the unity of the general aesthetic effect, and the variety of the bands (width, scale, and degree of relief of each respective decorative element). In this example alternation combines with repetition.

Fig. 8. The stalks of the leaves on this branch provide an example of alternation.

Fig. 9. Note the overlapping of the different parts of a plant which has developed in the form of a palmette.

Fig. 10. Here is another example of positional alternation in a natural object.

Fig. 11. The forms alternate along a closed curved line. Note the radial disposition of the repeating motifs along the curve.

Fig. 12. Motifs symmetrical in relation to the two medians of the rectangle are repeated. The effect of richness is increased by alternating wide elements with narrow ones.

Fig. 13. Example of a natural border.

Fig. 14. This slug displays a natural border decorated with a regular sequence of alternately long and short vertical lines.

8

9

6

10

11

7

12

13

14

15

19

16

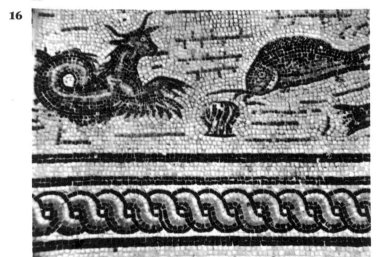

17

Fig. 15. Work by a Primitive painter (Dijon Museum). This detail shows borders decorated primarily with a repeated dot motif.

Fig. 16. Fragment of a mosaic (Lyons). A regular interlaced motif is repeated between the parallel lines of the border.

Fig. 17. Fragment of a mosaic (Lyons). A device repeated alternately along a regular sinuous line decorates the border.

Fig. 18. Shell. On this shell bands of different widths and values can be discerned. The last of these could be called a border.

Fig. 19. Window (Beaune). This is an example of decoration formed by bands interlacing at right angles. The very simple border consists of equal rectangles repeated in a straight line.

Fig. 20. Interlinked circles (Musée des Arts Decoratifs).

18

20

17. Planning a personal composition

THE DOMINANTS

In a work of art, 'dominants' are those lines, spots, values, colors, materials, etc., which dominate all others and impose themselves from the first glance. In a work the dominants underline the principal characteristics of a composition, they reveal the artist's standpoint, and, finally, they link the secondary elements and details with each other, thereby emphasizing the unity of the work.

Every composition should start with a sketch. Every sketch should start with a decision as to what are the dominants and where they should go. By this method you avoid losing the unity of the composition in a welter of detail.

PERSONAL COMPOSITIONS

When composing a personal work, bear in mind the following:

(1) Get a clear idea of what the subject actually is.

(2) To begin with, visualize the work in terms of its main masses and its main effects.

(3) Resist for as long as possible the temptation to put in details in the misguided hope that they might salvage what already appears to be going wrong.

(4) Keep the details to the end, by which time you will have decided which ones are necessary, and how much importance to give to them.

(5) Remove or tone down anything that might weaken or impair the unity of the composition, that is to say, anything that is not in harmony with the subject matter.

(6) Know when to stop. Often a hitherto successful work can be ruined by adding useless and consequently harmful details in an effort to improve it.

'Everything that does not have a use in the painting is, by that very token, detrimental to it. A work requires an overall harmony; each superfluous detail would, in the mind of the spectator, displace some other essential detail.' (Matisse.)

Roughs and sketches

THE ROUGH

A rough is the first imperfect and crude form of a work or an artifact. (See fig. 6, p. 34.) It describes the state of a work at the start of its technical and plastic realization. A work is 'roughed in', 'blocked in', etc., at the very beginning of its execution. A rough is said to be 'worked' or 'very worked' when it has almost reached that stage of completion that makes it a work in its own right.

THE SKETCH

A sketch is the initial form given to a work or an artifact.

A sketch contains, in an evocative or descriptive form, the essence of what the artist wants to express perfectly and definitively. A sketch is the first concrete manifestation of an idea, a feeling, an emotion, a plan.

A sketch is designed to serve as a guide to the artist when he proceeds to the actual execution of the work.

Note: Carried out as they are in one single burst of activity, under the influence of very strong emotion or particularly fruitful inspiration, some more or less worked sketches are preferable to finished paintings, for example, Corot's 'Bridge at Narni'. (See color plate 2, p. 17.)

DIFFERENCE BETWEEN A ROUGH AND A SKETCH

The rough is concerned with the technique or the medium selected for the realization of the work, with the materials to be used, and with the expertise required of the artist or craftsman.

A sketch is concerned with the artist's conceptual qualities, his imagination, his aesthetic sensibility.

A sketch is an affair of the heart and the mind, a rough is a matter of material means and techniques.

THE NEED FOR THE SKETCH

A sketch, a rough draft, a model, a study, a plan, an overall view of the projected work are precious guides designed to save us from the errors, weaknesses, and uncertainties of improvisation.

An artist does not paint a still life, a portrait, a landscape, or a decorative composition without having first ascertained in a sketch, or even in a series of sketches, which aspect he needs to emphasize, and which is the best way to achieve his aims without too many errors and erasures.

HOW TO MAKE A SKETCH

(1) *A subject taken from nature (a still life, for instance)*. On a sheet of paper draw several small rectangles in the format in which the still life will finally be executed.

In the first of these rectangles indicate very roughly the essential dominants: lines, values, areas. Decide at

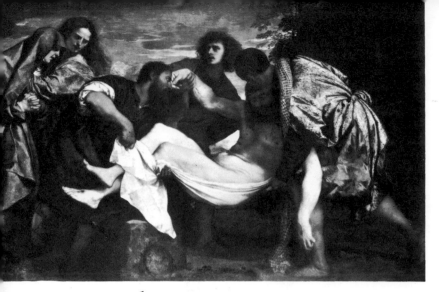

1

2

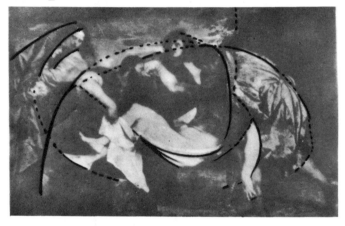

*Figs. 1 and 2. It is instructive to trace the dominant
compositional lines from reproductions of great paintings.*

the beginning which angle and which position show
the selected subject to its best advantage both visually
and aesthetically.

In the second rectangle repeat the initial overall view
outlined in the first rectangle, adding corrections and
improvements. Make the positioning more precise,
and intensify the desired dominant effect.

In a third, and a fourth rectangle, reproduce in a few
pencil strokes anything that was really satisfying in the
first sketches, particularly in the final one. Start to paint
with broad brushstrokes, and aim for harmony be-
tween dominants, whether of value or color.

When you are dealing with a natural subject, the
subject itself already represents a guide, so a study, i.e.
a color rough executed in broad brushstrokes, is more
to the point than a sketch. (A sketch is generally re-
served for works of imagination and memory.)

(2) *A subject that requires working from imagination or
memory.*
On a sheet of paper draw several small rectangles of
exactly the same format as that in which the final work
will be executed.

First impress on your mind the plastic and aesthetic
qualities you want to express. Then work out and indi-
cate, abstractly for as long as possible, the chief plastic
effects of line, color, surface, value, and material ap-
propriate to their expression. Avoid starting a sketch
with descriptive and anecdotal details.

In other rectangles experiment with other effects,
other ways of treating the subject, so that you can select
the best solution carefully.

Having made your choice, combine in one last
sketch the qualities you wish to retain from all the pre-
vious sketches, while at the same time subordinating
them even further to the aesthetic unity of the initial
conception.

Bibliography

THE ART OF PAINTING. Three volumes, Hawthorne Books, Inc., London and New York.

Birren. CREATIVE COLOR. Van Nostrand Reinhold Company, London and New York.

Birren. HISTORY OF COLOR IN PAINTING. Van Nostrand Reinhold Company, London and New York.

Birren. LIGHT, COLOR AND ENVIRONMENT. Van Nostrand Reinhold Company, London and New York.

Birren. PRINCIPLES OF COLOR. Van Nostrand Reinhold Company, London and New York.

Bouleau. THE PAINTER'S SECRET GEOMETRY: A STUDY OF COMPOSITION IN ART. A Helen Kurt Wolff Book, Harcourt, Brace & World, Inc.

Brandt. THE WINNING WAYS OF WATERCOLOR. Van Nostrand Reinhold Company, London and New York.

Brooks. OIL PAINTING – TRADITIONAL AND NEW. Van Nostrand Reinhold Company, London and New York.

Chevreul, ed. Birren. THE PRINCIPLES OF HARMONY AND CONTRAST OF COLORS. Van Nostrand Reinhold Company, London and New York.

de Sausmarez. BASIC DESIGN: THE DYNAMICS OF VISUAL FORM. Studio Vista, London, and Van Nostrand Reinhold Company, New York.

DICTIONARY OF MODERN PAINTING. Tudor Publishing Company, New York.

DRAWINGS OF THE MASTERS. Ten volumes, Shorewood Publishing Inc., New York.

Farris. ART STUDENTS' ANATOMY. J. B. Lippincott Company, Philadelphia.

Gore. PAINTING – SOME BASIC PRINCIPLES. Studio Vista, London, and Van Nostrand Reinhold Company, New York.

Graham. COMPOSING PICTURES. Van Nostrand Reinhold Company, London and New York.

Grohmann (ed.). ART OF OUR TIME. Thames and Hudson, London.

Hambridge. PRACTICAL APPLICATION OF DYNAMIC SYMMETRY. Yale University Press.

Hickethier. THE HICKETHIER COLOR ATLAS. Van Nostrand Reinhold Company, London and New York.

Jones, O. GRAMMAR OF ORNAMENT. Van Nostrand Reinhold Company, London and New York.

Jones, T. THE ART OF LIGHT AND COLOR. Van Nostrand Reinhold Company, London and New York.

Küppers. COLOR: ORIGIN, SYSTEMS, USE. Van Nostrand Reinhold Company, London and New York.

Lowry. THE VISUAL EXPERIENCE. Harry N. Abrams, Inc., New York.

Marx. THE CONTRAST OF COLORS. Van Nostrand Reinhold Company, London and New York.

Munsell. GRAMMAR OF COLOR. Van Nostrand Reinhold Company, London and New York.

Ostwald. THE COLOR PRIMER. Van Nostrand Reinhold Company, London and New York.

Read. A CONCISE HISTORY OF MODERN PAINTING. Van Nostrand Reinhold Company, London and New York.

Rood. MODERN CHROMATICS: THE STUDENTS' TEXTBOOK OF COLOR WITH APPLICATION TO ART AND INDUSTRY. Van Nostrand Reinhold Company, London and New York.

Woody. PAINTING WITH SYNTHETIC MEDIA. Van Nostrand Reinhold Company, London and New York.

Woody. POLYMER PAINTING AND RELATED TECHNIQUES. Van Nostrand Reinhold Company, London and New York.

Source of illustrations

Note: numbers in italics refer to the pages on which the illustrations are to be found.

Bernand: *65* (37)
Bibliothèque Nationale: *61* (7)
Bulloz: *96*
Cartier: *90*
Editions Jules Tallandier: *49* (14, J. A. Lavaud), *61* (6, D. Burnouf)
Galerie Chardin: *22* (1)
Galerie David et Garnier: *20* (1)
Galerie Denise René: 18 (3), *29* (1, 2, 3, A. Morain), *30*, *47* (4), *73* (2), *75* (15), *81* (30), *83* (44, A. de Menil)
Galerie de France: *18* (1)
Galerie Iolas: *43* (25)
Galerie Jeannette Ostier: *43* (26)
Galerie M. Knoedler: *29* (4, Cauvin)
Galerie 'Le Mur Ouvert': *35* (7)
Galerie Urban: *22* (3, 4)
Giraudon: *65* (36)
A. Held: *19* (6)
Hérold: *59* (8)
Hugon: *20* (2, 3)
Georg Jensen, Copenhagen (by kind permission of the Danish Boutique, Paris): *48* (6), *61* (12), *69* (22), *75* (14)
Mauboussin: *89*
Musées Nationaux: *17* (2), *18* (4)
J. M. Paillard: *35* (8, 9)
Rapho: *61* (8, Martin)
Roger Viollet: *48* (5), *67* (3), *82* (33, Alinari)

Scala: *17* (1)
Schuwer: *54* (4)
Selves-Albane: *18* (2)
Roger Vallet: *65* (38), *67* (2)
Marc Vaux: *54* (6, 7)

© A.D.A.G.P. (1969): B. Buffet, *20* (1), G. Claisse, *47* (4), Fontanarosa, *22* (1), Manessier, *18* (1), A. Marquet, *29* (4), A. Poncet, *54* (6)

© S.P.A.D.E.M. (1969): R. Dufy, *43* (23), P. Klee, *43* (25), Lorjou, *22* (3, 4), C. Monet, *21* (4), P. Picasso, *57* (28), A. Renoir, *21* (6), Rouault, *20* (2), M. Saint Saëns, *18* (2), Vlaminck, *20* (3), M. Vaux, *54* (6, 7)

The following photographs were taken by the author: *33* (1, 2, 3), *34* (5), *35* (10), *38*, *39*, *40*, *47* (1, 3), *48* (7, 8), *49* (9, 10, 11, 12, 13, 15), *50*, *51*, *52*, *54* (3, 5), *55*, *56* (20, 21), *57* (22, 23, 24, 25, 26, 27, 30), *58* (1, 2, 3, 4, 5, 6), *59* (9, 10, 11, 12, 13, 14, 15), *60*, *61* (9, 10, 13, 14), *62*, *63*, *64* (31, 32, 35), *65* (39), *67* (1, 4, 5, 6, 7), *68*, *69* (14, 15, 16, 17, 18, 19, 20, 21, 23), *70*, *71*, *72* (37, 38, 39), *74*, *75* (11, 12, 13), *78*, *79* (50, 51, 52), *81* (24, 25, 26, 27, 28, 29), *82* (32, 34, 36), *83* (37, 38, 43), *84*, *86*, *87*, *88*, *92*, *93* (7, 8, 9, 10, 11, 13, 14), *94*

All other illustrations are the property of the author, or come from the archives of Editions Nathan, Paris.

Index